CW00499768

# Londoni Bride

## A Modern-Day Slavery in Britain in the name of 'Honour & Izzat'

*Aklima Bibi*

*Published by Clink Street Publishing 2022*

*Copyright © 2022*

*First edition.*

*All rights reserved.*

*No part of this book may be reproduced by any means, nor transmitted, nor translated into any languages including any machine language without the written permission of the author;*

*Author: Akima Bibi*

*Aklima Bibi, Email: aklima.bibi@yahoo.co.uk/ info@aklimabibi.com*

*ISBN:*
*978-1-912262-41-0 - paperback*
*978-1-912262-42-7 - ebook*

*This book is dedicated to my children – to tell them why I wasn't always a perfect mother at home – and to all women of abuse; don't rely on the system to help you. Fight. Fight for justice and don't stop fighting until the fight is done. It might be difficult but it's not impossible. Remember, as a woman you have every right to basic freedom.*

# Contents

CHAPTER 1    The Beginning: The Patriotic Period of 'Amar Shonar Bangla'    9

CHAPTER 2    From 'Amar Shonar Bangla' to 'Amar Shonar London' – 'Rani-r Desh': Great Britain – Land of the Queen    15

CHAPTER 3    Bachelor's Dream Getting Desperate – Tactics to Gain the 'Londoni Bride'    25

CHAPTER 4    The Marriage    29

CHAPTER 5    Life After The Wedding – Arrival in England    37

CHAPTER 6    The 'Bad Girl'    45

CHAPTER 7    Marriage Ends    49

CHAPTER 8    The New Beginning of the New Marriage – to my Second Husband    51

CHAPTER 9    Life After Marriage to my Second Husband – 'The Living Hell'    55

CHAPTER 10    The Escape to Rising Success    61

CHAPTER 11    My Battle with the Past and Present – 'The Lady Still Stands'    67

CHAPTER 12    End of the 'Living Hell' with my Second Husband, the Present    79

CHAPTER 13    My Father's Pride and Joy, Third Generation of our Kids & My Final Chapter    89

CHAPTER 14    'Honour and Izzat' of Women and Marriage in Islam    93

CHAPTER 15    Political Involvement of Women in Islam    97

About the Author and This Book    99

Summary    100

Bibliography    101

Extracts of My Life    102

# CHAPTER 1

# The Beginning: The Patriotic Period of 'Amar Shonar Bangla'

I was born on the 15th of March 1972 to a fortunate middle-class Sunni Muslim family – known as the 'Talukdar, Shah' family – in a village in the Sylhet District of Bangladesh. I am the eldest child, and the only girl out of six children.

I had a large extended family consisting of about a hundred people whom my father – who lived and worked in the United Kingdom – supported with his earnings. As, in those days, the family had ample food supplies from agriculture, my father's earnings were used for buying or increasing land and other assets for the extended family, in order to increase their 'Zamidari', or landlord traditions.

I had a very good childhood in Bangladesh. People lived without electricity, houses were made of traditional mud (known as 'Bangla'), and there was no running water... but there was life. People loved, cared for, and shared with each other.

Most importantly, people looked out for one another and children played freely, without fear. Harvesting time – or the 'Boishaki' – was a tradition of thanksgiving, and of joy and laughter. Hundreds of family members, friends, and neighbours gathered together, and there was always enough food for everyone. Huge cooking pots were used; big holes were dug in the ground, and firewood or rice hay was used to cook the food. We had the famous sticky rice (biro-in chaul), koi fish, the homemade 'gai-ah ghee', the 'mata fakh' yoghurt, and of

course the homemade rice flour 'pittas' (pastries). 'Not enough food' was simply not in our vocabulary.

My favourites of the children's sweets were the 'tilu' (round, white, marble-sized sweet balls), the 'lebon' sweet (which tasted like lemon), the 'ladu' rice balls with syrup, 'bettor' koi (waterlily fruit balls, made the same way as the rice balls with syrup), and the famous 'ghee som som', which was a brown chunk of a sweet, made by heating up sugar and water together until the solutions turned hard and brown. We were able to buy these sweets by trading broken glass with traders who came to the villages.

We had many celebrations, but I have to mention the ladies' fun and laughter events – the 'binala' or the 'wish singer'. This was where ladies and girls gathered round on a mat (the satee) and filled up the water pot (the badna), with flowers floating on the top. A little girl was always chosen to be the pot/'badna' holder. Everyone then put an item of their worn jewellery into the pot, making a wish. The ladies chose a song – which normally focused on an actual meaning or some kind of story – and after they finished the song, the little girl who was the water pot holder would put her hand into the 'badna' and bring out the first item of jewellery she came across. The jewellery – and the wish of the person the item belonged to – would then be analysed with the song, giving her the findings to her wish. The wish never turned out to be true, but the 'binala' was fun to do anyway, as afterwards it would turn into a water fight between the ladies.

As children, learning to swim was a must, since Bangladesh is largely underwater for around six months each year and the danger of drowning was a real possibility. I remember how my older cousins would be tied up to the younger ones – including myself – using banana trees that had been chopped into pieces, and how they would tell us to kick until we could swim, otherwise we'd be eaten by the snakes that swam around us in droves. Mostly, these were harmless black or brown and yellow snakes, but we were fearful of what the older kids said, so we had no option but to learn to swim fast. Personally, I could swim by the age of four; I would swim further out into the

open water to eat the waterlily fruits, the 'beht', 'suki', and 'keso-ir' (different types of water plant fruits), and of course the 'hing-rai' (a small triangle-shaped water plant fruit).

Even when the water disappeared after the flooding season, the water that was left behind around the paddy fields produced other fruits and vegetables such as the 'haluk', which is normally found underneath the mud in the paddy fields. We would wash and scrape the skin off these and then eat the white part. Children had to eat wild fruits and vegetables as there were no shops anywhere, but that didn't matter; we loved these natural wild foods.

I clearly remember my mother, my father's sisters, and my uncle's wives swimming in the village ponds looking for oysters – they were hunting for pearls. They found many oysters each time they dived deep into the bottom of the pond and, when they opened them, they found beautiful pearls in every single oyster. The size and colour of the pearls would be slightly different in each one as it depended on the size of the oyster, but nonetheless, there were pearls in our village ponds – and so many as well. There were no markets at which to sell these pearls but I can remember men coming to the villages, asking to buy them. Pearls weren't regarded as valued items within the village environment but I suppose these men went on to sell them at the city markets for a much higher price. A lot of the times the pearls were made into stud earrings, and the smaller ones into nose studs.

There is nothing of this sort nowadays; the many high-valued items found around the world are nothing like the natural, precious items that were available in the villages back then.

To us, Western cultures weren't even heard of. In fact, people laughed at my father when – at the age of 19 – he was arranging to move to England, having completed his education. I suppose there was no need at that time to make such a move.

In those days, there was less Western influence on our country. Money and material worship was simply not part of our culture, and there was little to no modern technology – just simple village life where traditions of hard work and caring for family, friends, and neighbours was appreciated.

As a girl child born to a 'Londoni' father (read London-e), I was spoilt by my uncles, aunts, and other relatives who called me 'our million dollar baby' (or 'Am-rar lak takar beti'). They would take me to boat races and bullfighting events or even fishing (doratana) even though, normally, girls were not allowed to attend these events.

I also remember how certain family members, such as my grandmother, my father's sisters, and my cousins, would wish me a better life. It was as if they were dreaming my dreams of better things to come. I was a wild child, often out with my cousins or other village children, climbing trees, fishing, stealing vegetables from fields, and taking boats for rides in the monsoon floods. I sometimes wonder how I managed to control a boat on my own with a bamboo pole, as it was about 20 to 25 feet long. When we couldn't find a boat to steal we would make our own from the 'boora' – chopped up banana plants – tied up together to make a raft.

We also hunted birds using the 'kafi' method, which involved catching birds on glued sticks. For this we had to make triangle-shaped sticks that could be pushed into the ground, and we would get glue by cutting a slit on a tree skin – the sap that came out turned out to be a very strong glue substance. We would then spread the glue on our triangle-shaped sticks, hang an insect or other creature – normally a big spider – on a thread between the two triangle sticks, push the sticks into the ground, and then wait for a bird to see the insect or spider moving.

In order to eat the insect or spider, the bird would land on the triangle-shaped sticks with the glue spread on it and, as the glue was very strong, the bird would get stuck there. With the bird being unable to fly off, we would go over and catch it. I won't mention what happened to the birds afterwards, as it was a bit sad. I would never ever think of doing this now; those tropical birds are very precious and beautiful and, unfortunately, most of them have disappeared.

Even though I was very young at the time, danger was never an issue for me or for any of the other children in those days,

because my older cousins and the other older children in the village always looked after the younger ones. This was an implied duty and responsibility that came naturally, and not one that was imposed upon them by their parents or other elders.

Meanwhile, the time came when we had to join my father in the United Kingdom, which meant obtaining the appropriate visas. There were a number of occasions when we had to travel by train to Dhaka for visa interviews, and as transportation was limited, the journeys were always long and hard. A lot of these journeys were on foot. I remember seeing my hungry and exhausted mother carrying my one month old brother, bare feet through a single bamboo bridge in the middle of the night. No lights other than the moonlight in the sky. The bamboo bridge was about 60ft long and with a very scary drop. Also myself; I carried a two year old sibling through rough paddy fields in bare feet, when I was only seven years old.

It would take us about ten hours by train, often setting off from Sylhet in the middle of the night to reach Dhaka by morning, ready for the interviews. I remember how my brothers and I would accompany my mother for these interviews. The visa applications, however, kept on being refused because – as I came to understand later – my father would put down his brothers' sons as his own. The funny bit is that one of them was almost the same age as my mother, but you couldn't tell as she was made to wear a burka, totally covering her face and body. She also had to lie to the interviewing officer, claiming that the boys were her children, the obligation to lie having been put upon her by her in-laws.

There was one particular occasion when we attended the British High Commission for a visa interview, and as we entered the embassy, one of my uncles – who'd accompanied us – held my hand. It was then that a white woman drove past and parked in front of the embassy. As she got out of the car, my uncle said to me, "Look, that is you, driving in England." I looked at the red car and the woman with a heartfelt gaze. Again, it seemed that everyone in my entire family – and my

village – were already visualising my dreams and my future in England… dreams of better things to come.

I recall that all children respected their elders and all adults loved every single child in the family, treating them all as their own. No wonder that, as children, we referred to our aunts as mothers, just like our own mother. Even to this day my mother gets called 'Mother' by all my cousins, regardless of any familial misunderstandings.

Back then, there were no barriers because I was a girl; indeed, I had a lot of privileges. As a child, I could remember life being 'perfect'. There was so much love and care, and when I think back I am constantly surprised by the things I did in my childhood.

These are my precious memories – my childhood in Bangladesh, and the true period of the 'Amar Shonar Bangla'. Unfortunately, I'm not very optimistic about that life ever coming back, as advanced technology, education, money, and Western culture have all driven away what was once a beautiful tradition of the 'Shonar Bangla' period.

Nowadays, as in many countries, money has created greedy and envious people. These cheats, liars, and greedy people of the modern-day world have taken over those 'Shonar Bangla' traditions and cultures that I wish could be brought back. Unfortunately, I know the world is full of power, politics, and pride, and even in the villages, I doubt it will ever come back.

These immoral modern-day people are bringing in unethical cultures – where brothers kill brothers, sisters and daughters are regarded as burdens, sons leave destitute mothers to please their wives, husbands and wives commit acts of unfaithfulness to each other and, of course, there is corruption in the authorities. Now, it is all about the 'survival of the fittest', and the dying out of the less suitable. That is what power, pride, and of course the politics of the modern-day twenty-first century world dictates.

The true 'Shonar Bangla' tradition has been killed, never to rise again. I would be a fool to talk about this ever coming back, and with that, my childhood in Bangladesh came to an end.

## CHAPTER 2

# From 'Amar Shonar Bangla' to 'Amar Shonar London' – 'Rani-r Desh': Great Britain – Land of the Queen

After a long struggle, in March 1981 we managed to obtain visas that allowed us to travel to the United Kingdom, where we would join my father (who'd been settled there since the age of 19). I was just eight years old.

When we arrived in the United Kingdom, we lived in my father's two-bedroomed terrace house at number 41 Cromwell Road, Luton. I was fascinated with all the people from different backgrounds, especially those with Afro-Caribbean hair, which when curled up on their heads looked like the 'jambura' fruit in Bangladesh. The other fascinating thing about the land of gold was the street lights – there were just so many lights on the street, not to mention on the cars. The food was so different too; I'd never seen such big potatoes and onions in my life. The other thing, of course, was the English language. I couldn't wait to learn and speak in English.

My father had enrolled us into schools, and while I attended Denbigh Junior School, one of my brothers went to the Infants school and my so-called eldest brother went to Stockwood High School. My other brothers were too young to attend school and so stayed at home with my mother.

I was very keen to learn the language, and I quickly became attached and devoted to my form tutor. As I was also devoted to learning, she was keen to teach me – even after school hours. With this help I was able to learn really fast, especially when it came to the English language. Fortunately, we had swimming as part of our physical education programme, and on my first day of attending – which was about two weeks after I'd started school for the first time – my tutor was shocked and amazed at how well I could swim. Little did she know that I'd just come from a country that was underwater for six months of the year. I had swum with the many types of snakes, water rats, mongooses, leeches, and anything else that had been washed away in the waters – including dead animals and sometimes even dead people. Swimming well enough at an early age was just part of our survival.

The tutor arranged for an interpreter to ask me if I'd be interested in representing the school in a swimming competition, and although I didn't know what a competition was, I was curious so I agreed. My tutor was very happy and arranged for me to attend training. All the other girls in the competition – which was against the other junior schools in Luton – were English; I was the only girl from an ethnic minority. My father attended the competition with my brothers, which was held at Bath Road swimming pool in Luton, and I believe our school came third.

I started making friends and mixing well with the other students at school, as well as with our neighbours. Even though other girls played with dolls, however, I wasn't so keen on playing with 'girls' toys'; I was more keen on finding trees to climb and going fishing, but as there weren't any obvious facilities for that sort of life, I had to settle for playing football with my brothers, as well as catching fish in my own way. I'd catch small sticklebacks from a stream that passed through Moor Park near my home. I also liked breaking through the train line barrier on Moor path to steal apples from the apple trees with other children from my neighbourhood. I certainly continued with my wild life even in the United Kingdom.

My father had bought my eldest brother a bike and, as I always tried to take it off him to go for a ride, he could see that I was interested in riding. I believe this persuaded my father to buy me a second-hand bike, which was a truly joyful moment for me. It had only been a short while since I'd arrived in the UK but I was learning the way of life very fast, and I always wanted to improve and better myself. So, I rode this bike – without any hesitation or fear – all around my neighbourhood.

I also remember my mother teaching me how to be a good wife while she learnt how to sew at the house of my father's friend and his wife, who lived two doors down from us. At that time the home sewing profession was very much in demand and my mother was able to quickly pick up the skill from her neighbour. Within months of arriving, my father bought my mother a sewing machine, and she slaved away day and night earning extra income that my father would send back to his brothers in Bangladesh, to increase their assets and to maintain his extended family back home. Meanwhile, my father worked for Vauxhall Motors as a production worker, a job he'd been doing since arriving in England in the 1960s.

In 1986, my father's older brother was shot dead when he went to pick up his son, my so-called 'eldest brother' from the airport in Sylhet, Bangladesh. The incident happened when they reached the village and an argument erupted over a dispute with the local road. He was apparently shot by another 'Londoni' man from the UK, who was the brother of a local politician in Sylhet.

My father and other villagers were desperate for action to be taken, which meant that lots of money was needed in order to deal with the criminal justice system in Bangladesh. This is because nothing – not even murder cases – could be properly investigated by the police without a bribe. Unfortunately, this meant my mother had to work twice as hard, as she wasn't paid weekly or hourly but by the number of pieces she completed. For each piece she earned around 20p, with the highest being about 80p. This was, of course, slave labour, which nowadays

would be termed as unlawful and totally illegal, but in those days it was considered alright. A lot of pressure was put on these women when they arrived from Bangladesh, but their efforts often went unnoticed and unappreciated. This, however, was the reality of slave labour for women like my mother in 'the land of gold', while the Sylheti women – like my father's younger brother's wife in Bangladesh – were recognised as high society women at my mother's expense.

As time went on, my mother had to do more and more work to help my father pay for the court case to seek justice for his dead brother. His own son – my so-called eldest brother – wasn't bothered about his father's case; instead, he went abroad to Spain, saying, "The dead are gone, why are you wasting your money on court cases?" My father answered, "If we let a lower class man murder my brother – your own father – then what is the point of being a 'Shah', a Talukdar and Londoni, if you cannot live up to your good name and keep the family honour? If he gets away with this murder, he can get away with anything the next time. How can you show your face in Bangladesh again?" This did not, however, persuade the son to make any contributions, and he left for Spain anyway, leaving the financial burden to my parents.

I witnessed my mother's stress and tiredness while she worked non-stop day and night – sometimes for up to 23 or even 24 hours a day – to help my father, while still maintaining the daily routine and doing all the house chores. Feeling sorry for my mother, I started helping her out by doing some sewing, first the simple stitching on the sleeves, then putting on the collars, then the cuffs, and so on. Eventually I managed to do a lot more and my mother managed to take breaks, but only to do other housework. One day, the boss of the factory – who was Jewish – came to collect the finished garments from my mother and he saw that I was working on my mother's machine. As my mother was one of his best machinists, he gave her a sewing machine from his factory for me to use. Despite us being Muslims and him being a Jew, I felt that he adored our

hard work and commitment, and that he did what he could in terms of paying us the best possible rate. Nevertheless, health-wise the work was absolutely horrendous, but we simply had to do it. Being tired was not in our vocabulary, especially in my mother's book of 'being a good wife'.

With the new sewing machine awarded to me by my mother's boss, I was able to help my mother even more. With both of us working at the same time, we managed to complete more garments, which meant more money for my father – not much, but at least more than it would have been.

I was 13 and still in school at the time, but I knew I had to help my mother. So I did, often staying up until about 2 a.m. to sew with her. My mother even worked as a machinist in order to help my father and his family for the full length of her pregnancy with my youngest brother.

My uncle's murder case lasted over two years, with the legal bill growing to about 80 lakh taka – the equivalent of £80,000 (current rate). The perpetrator was sentenced to life in prison, but by then he'd come back to England. The Bangladesh government had issued an order for the British government to extradite him back to Bangladesh, but instead the man came to my father and apologised. My father forgave him and requested the order be revoked. As a result, the murderer never went back to Bangladesh to serve time and later died here in England. It was never about forgiving the perpetrator; it was more to do with keeping the tribal honour – or the family honour – as well as winning the court case. Even to this day people talk about how so much of my father's monies were paid to the authorities for the murder case, and how my father never gave up trying to keep his tribe's honour.

According to my uncle, at the time the case was the talk of the town in all the local bazaars, with men telling each other, "Big sacks of money in 90ft long boats were transported through the rivers to the cities in order to pay the officials."

"Is it true though?" I asked my great uncle. He replied, "Of course it is true," and went on to tell me about how the cash

collected from the bank was stored at the time in giant solid wood storage units called 'fethi', guarded by men with spears, as the houses weren't secure enough and could be easily raided.

The honour of my father's family and tribe was not lost after all, and to this day his tribe still walk proudly with their heads held high, knowing they are the most powerful tribe in the area. But was this sacrifice to keep the family/tribal honour worth it?

We had to slave away so my father could pay for this murder case, while the victim's own son did nothing to help. And not only did we have to slave away for this case but we also did it to feed my father's extended family in Bangladesh. When it came to us – his own children in the UK – he used to count every penny he'd spend on us, including making us live in the cold to save on heating bills. He rarely gave us any pocket money either, though that was common for Bangladeshi men who arrived in England at that time. I didn't even have any underwear or sanitary pads initially, until I managed to scrape up a few pennies here and there; instead, I had to wear my brother's used underwear and use old cloths as sanitary towels. Yes, life was shit on British soil when I was young, but I wasn't the exception; it was the same for many of us girls at the time.

I suppose that now, we can look at this in a positive way or a negative way. Personally, I tend to look at it in a positive way, as my father used to say to me, "This is the country of opportunity, use it," teaching us to stand on our own two feet – though at the same time he was teaching his extended family to rely on him and be lazy by giving them money every time they asked for it, without question, and in turn, sacrificing his immediate family's needs. This included the damage suffered by my brother before he was even born due to those bloodsucking parasites of an extended family, who seemed to be more important to my father than his own children.

This was not peculiar, as many other men from Bangladesh did not think of their own children's welfare but did consider the welfare of their 'back yard extended family', who are usually nothing more than 'bloodsuckers' and 'scavengers'; people who

just want to live off their family in the UK rather than working to better themselves, or using the money they were given in order to better themselves through education or by learning a profession. They want monthly remittance from the UK so they can just 'eat, shit, sleep, and look and feel good' at our expense, not to mention their desire to come to England. The request "I want to go to London" is a common one even to this day, and those lucky enough to have British female cousins living in the UK have an easy life, thinking, *"I'm already a Londoni; I do not need to work."* Sadly, many of these British girls are forced to marry these men in order to facilitate their coming to the United Kingdom.

I worked with my mother as a machinist until I got a job as a receptionist at a local sign makers – all before I'd even left school. I was very pleased as not many Bengali girls get any jobs, let alone office-based ones. All my friends and the girls I knew from school applied for office training and typing – the normal college courses for girls at the time – but most got married instead, as their parents were anxious to use their daughters to bring male family members into the United Kingdom.

Even with all the restrictions a Bangladeshi girl faced, through my school's careers advisor I applied to train as a military nurse with the UK Territorial Army, rather than doing the usual clerical/office training like everyone else.

I knew my father wouldn't approve of it – especially considering the conflict between the IRA and the British government at the time – however, I took the risk just as I've always done. At the same time, one of my teachers gave me the telephone number of a company who needed office staff, advising me to phone them. I wasn't optimistic, mainly because no other girls were getting any jobs, but I went home and applied to them over the phone, along with three other companies. They all gave me an interview date, all on the same day but at different times. I wasn't sure if I would succeed, but I went along to the interviews out of curiosity – and to test myself.

I was offered the job at the local sign makers – the first interview I went to – within one hour! Shocked and pleased, I took the offer straight away. I asked why they chose me, and they told me that I was very confident for a schoolgirl on a first job interview, and that I looked sincere and honest – they also liked my big cheerful smile.

The next day, all the other companies phoned me one after the other, each one offering me a job. My father was very pleased, and I really didn't know what to think. I can remember my father being over the moon with my first job, which paid £55 a week – a lot of money back in 1988. I was also offered the military nursing training, but the independence that came with earning my own money was too great to ignore, so I declined that offer and all the other offers to take the first one.

I started the job one month before I left school, and my first wages were sent back to Bangladesh for distribution as charity. After a few months, when I had more experience, I got more curious and searched for higher-paid jobs, getting a role as an engineering assistant for a computer manufacturer called Spectrum Group, which paid £75 a week. Then, a few months later, I got a job working for the Luton Borough Council as an engineering administrator, which paid £175 per week. This was overwhelming for a girl who'd just left school and was barely 16 years of age. It made a massive impression on my father too, and he boasted about me to everyone in our community, many of whom came to see me, praising me for my success. I gave all my wages to my father throughout my employment, until I got married.

Ever since I'd entered the United Kingdom with my mother and my siblings, all my parents talked about was marrying me off, even though I was still only a child. My mother wanted her nephew – the only son of her elder brother – to marry me, but my father preferred his own nephew. These arguments were not about my happiness, but about their ill gains – they were about whose nephew should come to the UK at my expense. I was taught by my mother to love, honour, and respect my husband

in order to secure my place in the afterworld. "Your heaven lies under your husband's feet," she used to teach me.

My father being at work all the time meant that my mother's brother had the perfect opportunity to convince his baby sister – my mother – to pursue their marriage plot to have me marry their appointed groom, my mother's nephew. Eventually, it was decided that I was to marry him – after a trade-off. I cannot go into any details of the trade-off between the two families, but I was traded in by my father when I was just nine years old, and I think that says enough.

# CHAPTER 3

# Bachelor's Dream Getting Desperate – Tactics to Gain the 'Londoni Bride'

Around the same time, my uncle kept lavishing me with expensive gifts like clothes, cassette players, writing pads, and floral notebooks. Now I knew why Bangladesh was so famous for its bribery; the teaching of taking bribes starts at an early age. My uncle also taught me how to write Bangla, and little did I know that, slowly but surely, the teaching of Bangla would turn into, "Why don't you write a letter to your cousin?" – his son.

He would post these letters and I would get replies back, and this carried on until his son started writing what can only be described as love letters, although nowadays these would probably be considered no more than basic teenage friendship letters.

This letter writing was an ambush, as my uncle later used the letters as leverage to convince my father there was a love affair between us – and, therefore, he should approve the marriage as quickly as possible. My father was even blackmailed into trying to have the marriage conducted without his presence when I was only 14 years old and had gone to Bangladesh on holiday.

However, as my father was fairly well educated, he knew that if the British authorities found out about this arrangement, he would be in big trouble. He therefore refused, asking them to

wait until I was 16 years old, which was the legal marriageable age with parental consent at the time.

The potential groom's dreams of England were now getting desperate; education for the only son, the bachelor, was getting to be a tough task. As a result he started pressuring his parents, and – in protest – he even went to Lebanon in 1986 during the war, hoping to persuade his parents to urgently arrange the marriage. He got his wish: it was arranged. I must have been about nine years old when I was first considered as being engaged.

In order to convince my father to agree without further protest or delays, my uncle – my would-be father-in-law – came up with a very appealing offer. It is amazing how he managed to think of something like this, and I have to give credit to the man for coming up with such an appealing plot: he offered my father a trade price for me, as stated earlier.

So, if it was my father's wish for his brothers and nephews to have a luxurious life and high status in Bangladesh, even if it meant trading his only daughter, then so be it! As long as my father's brothers and nephews – and the Bangla version of the Ku Klux Klan – live lives of luxury, who cares about the daughters in my father's family? It was the sons that counted.

It simply didn't matter what the daughter ended up with or how hard she worked; it was the sons who always got praised, and for the tiniest things – they'd even get praised if they farted! In my father's philosophy, girls weren't even third-class citizens. In fact, my father's youngest brother was his favourite because his wife gave birth to five sons and no daughters. Masha Allah for my youngest uncle, as he, his wife, and his sons are truly my father's favourite members of the family.

You might wonder, since my maternal uncle or my would-be father-in-law was applying for his wife and daughter to join him, why did he not bring his son to join him in the UK himself, rather than bribing my father for my hand in marriage?

My maternal uncle hadn't brought his family over before as he thought that children should not have a better life, and that

they should not be more intelligent than him, otherwise they would not respect him or look up to him. He was angry, in fact, that my father was bringing his family to the UK. He said that since he and his brother, who was also my father-in-law (my second husband's father) were not bringing their family to the UK, my father should not bring his family either. My father's response was: "I need to do what is best for my family, for my children. Who are you to tell me what to do? Do you feed my family?"

My uncle even resorted to slandering his own sister – my mother – telling my father not to go complaining to him if she ran off with another man. His exact words were: "I know my sister better than you, so don't come to me if she runs off." My father naturally replied, "If your sister runs off with another man, there will be many other women for me, so don't worry about that!"

Meanwhile, his son – my fiancé – reached the age of 18, which made him an adult of independent means. Therefore, he was not allowed a visa as a dependent relative.

My uncle or would-be father-in-law's side of the agreement to my father, however, had already been fulfilled, meaning I was the unfortunate British bride who would marry his son. The image of the pound was no doubt flashing before his eyes – the 'Londoni Bride' on their 'plate' at the time. My father knew he couldn't back down from his word, especially now that they'd fulfilled their side of the bargain.

My father's nephews came to England, to add to the thrones of the male 'Shahs' already present. Finally, here was his pride and joy – even if it meant trading his only daughter. As long as his 'back yard' family were happy, then my father would be happy too. The uneducated scavengers!

And so it was arranged that I would be married off to my mother's nephew, the eldest child and only son of my mother's eldest brother. I was still only a teenager.

# CHAPTER 4

# The Marriage

The wedding date was fixed, and I travelled to Bangladesh in the sweltering heat of July, as soon as I left school. I travelled with my father, against my will. No one – absolutely no one – helped me, and if they did have the intention of helping me it was only because everyone else was after me too; I was their ticket to the land of gold, England. Mentally, I was messed up, and I felt incredibly caged… stuck, imprisoned.

Being the leader of the household, my would-be mother-in-law had travelled a month earlier, but without the groom's father and without the bride's mother. So, neither brother nor sister attended their only son and only daughter's wedding, the cousins marrying in the absence of their parents – what a sham!

The FCO's Forced Marriage Unit came over 25 years too late for so many of us unfortunate 'Londoni Brides' whom our fathers couldn't wait to marry off, often organising weddings before we'd even left school or had the chance to grow up, simply because the male family members were too important and too anxious to come to the UK.

I was just a teenager, and already I was mixed up in a turmoil of emotions, blackmail, and manipulation. I was being pulled from all sides, each side wanting me to be a Londoni Bride.

There were other family members who were even trying to have me kidnapped for marriage. I was the only Londoni girl in my family on both my mother's side and my father's side, which meant that the family only had me as a means of getting

a visa to enter England; as I didn't have any other sisters to share the burden, everyone was desperate to take me.

Outsiders didn't stand a chance of getting anywhere near to proposing, and so were only 'looked on' by this Londoni Bride – not a girl and not even a human being, but simply a ticket to the UK – from a distance.

As if I didn't have enough to deal with, I was also being chased by a raven with a talisman around its neck. Yes, as freaky as it sounds, it was a raven with a talisman on its neck! The raven never managed to come near me, however, due to the fact that everyone surrounded me every time I stepped out of the house, ready with spears and sticks to kill it. I was told it was 'voodoo' magic, and that someone had cursed me; as I was told, the raven's mission was to touch me while it had this talisman on. It was like a scene out of a horror movie.

I didn't know why the raven was after me as I was nothing more than a caged bird myself, surrounded by primitive cave people.

The wedding date was fixed for the first of August, because many other suitors – mainly my cousin (my mother's sister's son), who was the strongest of the competitors – were planning to sabotage the wedding plans by kidnapping me. With this hanging over their heads, they needed to set a date as urgently as possible.

I remember my would-be mother-in-law being so loving, and giving me so many gifts and sweets – as well as giving lots of 'deeds' to my father. At the time I wondered what they were, but later I discovered that she'd taken out every deed and had given them to my father as she wanted the wedding to happen urgently. She needed money, so she sold these to my father in order to raise the money she needed for the hurried wedding. After all, she didn't want to lose a Londoni Bride, did she? So, in return my father gave her the money, and he also put the land/assets in my name as his gift to me.

I would have been happier if my father had been able to dig a hole with the assets he gave me and bury me in there. To me, this marriage was death.

As a teenager, and throughout my entire childhood, I'd dreamed of true love; I didn't believe in sex before marriage or having boyfriends, which was totally against my morals and ethics. I wanted to find a Raaj Kumar type, my prince, my knight in shining armour, someone I could truly love, honour, and respect – I didn't want to be forced into marrying someone I hated. Now, of course, my dreams were shattered. Instead of knights in shining armour I was surrounded by visa-seeking 'cunts in tin foil'.

Just before the wedding I started screaming loudly, but although there were many people from the village there, no one dared challenge my father – and of course my mother wasn't even with me; she was in England!

I was picked up and literally thrown onto a boat by my so-called eldest brother to be taken away like some sort of item that had just been bought. I had no one to accompany me, and I couldn't run away because the whole place was surrounded by water, infested by snakes and leeches.

I was still screaming on the boat, but this time the groom and his crew of about 200 people (spread over two or three boats) were in control and, knowing it was pointless, I soon stopped screaming and I think I passed out. I was left on a separate platform or cabin, inside the 'engine boat' or 'enginer nowka,' which had come out fairly recently. No one would come near me as they thought I'd hit them, and they were even more scared as they thought I was possessed – this was what the groom and his family were claiming in order to convince people this wasn't a forced marriage against my will.

It was almost evening when I reached Tano Gow, Hussain Purr, Osmani Nagar, the village of my in-laws and my new home. I was taken to this destination by boat, rather than by road, in case I got hijacked by other desperate United Kingdom visa seekers – mainly my mother's sister's son, the strongest competitor. Even the wedding reception had to be cancelled.

By this time I was incredibly distressed, upset, and lonely. It was Bangla summer – humid and sweltering, with a heat of at

least 47–48 degrees – and there was no electricity or running water in the remote village. I was very hot, and being a 'chubby' teenager didn't help either; I was sweating badly and the heat was getting to my head.

I was taken into a room and given coconut water – which I drank straight away – after which I was given another drink, which I threw over the woman who gave it to me. I also threw a glass at someone's face, which was a near miss, or perhaps I did hit them but they didn't complain – after all, there was a lot of drama to watch.

I threw the glass because I was angry at the way so many people were looking at me, with some of them saying, "Koinna je shundor, Fu-ra Beder meh Jusna" ("The bride is so pretty, exactly like the actress Beder Meye Josna"). I was given more coconut water, this time by the groom himself – it seemed his mother and two of his friends had brought it in especially – and I drank it because the heat was too much to bear.

When the night came, I couldn't make out whether I was dead or alive. I could hear many people talking and laughing in other rooms, but I couldn't make out who they were. I could see my so-called husband, his mother, and another man with an imam (Muslim priest) next to me, saying I was possessed and giving me some 'voodoo' treatments – or whatever they were chanting – but I didn't have the strength to shout, move, or even speak. I was just lying there, numb. To hell with my *fucking family*, I thought, *where were they when I needed them?*

Later that night I woke up to feel a figure lying on top of me, taking my clothes off. I didn't know what was happening to me – whether I was dreaming or if it was happening to me for real – but I found myself unable to move, scream, or even speak. I felt so sick at what was happening to me, and although I wanted to push him away I didn't have the strength, and nor did I have a proper sense of what was happening to me. Was I being raped?! I desperately wanted someone to come and take me away from this hell, but that didn't happen. Why was God so cruel? Why was God punishing a girl for wishing for true love?!

Not only had I not wanted to marry this man, but now that I was married to him against my will, he wasn't going to give me any time to recover. Instead, he'd put alcohol – as well as some other drugs – in my coconut water. I later found out that this was why I'd felt so sick and numb, as well as being the reason for me being unable to move, scream, or make sense of what was happening to me.

I could feel everything happening to me, and I felt sick that I was being molested with force and raped, but I couldn't do anything. I couldn't scream, move my body, or push the person away. I was just a lifeless body feeling every sick act of rape being forced upon me. Eventually I just gave up and let him do whatever the 'fuck' he wanted. Clearly, the God I was brought up to believe in wasn't going to help me!

The main evil people were the friends of the groom and his family, my mother-in-law, and the desperate groom himself. I was the teenager whose honour, dignity, self-respect, belief, and dreams of finding a knight in shining armour were taken away in an instant when I was drugged and raped.

I'd kept myself clean and pure for the right man, the man whom I'd waited to love, honour, and respect. Although I'd wanted an arranged marriage, I didn't expect a forced marriage, and nor did I expect to be raped. This was one night I needed to try to forget, but how could I?

I did not keep myself clean and pure just to be raped! And people wonder why I'm so fucking crazy!

I knew then that my life would never be the same again. My mind had been messed up, my innocence robbed from me the moment I was raped. I hated myself because I didn't know who I really was, and I didn't know who I hated more – myself, my parents, or the people who'd done this to me. I wanted to kill them for what they did, but who was I going to kill? They were my own flesh and blood, my own family. Not knowing who to blame for this evil act only made me hate myself more. In that instant I lost my self-esteem, my honour, and my dignity.

I managed to sleep all the next day, and when I woke up I wasn't sure if I was dreaming. I just felt so sick, and all I could say to myself was, "You are not worth anything, you are married, he had sex with you. You are not worth anything, forget about love, just be a wife. No one else will marry you now, no one else will take you now."

I actually convinced myself that there was no other life and that this was it: there was no escape. I hate to admit it, but even to this day I feel so depressed about myself, believing I'm not worthy enough or *pretty enough for any man to love me.*

I accepted what happened to me, only because of the shame it would have brought me not to – and besides, who would believe me? I had no one to talk to or turn to, so what was the point in crying?

No one was going to take me away to a better life; the dream of Prince Charming was just a myth, a fairy tale… certainly not a reality. So, I kept my pain and sorrow locked away inside, and tried to put on a brave and cheerful face in front of everyone – even though I was dying inside. I can't explain this, but even to this very day it haunts me, and when I think about it I hate myself all over again. Nevertheless, I tried my best to forget and be what they'd made me into: a wife.

Just two days after the wedding, at about 10 p.m., my husband suddenly fainted, with what I thought was a heart attack; he was clearly in severe pain, gripping his chest. Everyone panicked, especially his mother and sisters and the other house guests. I thought he needed a doctor, but his mother and other relatives – including his best friend – hurried to get their mullah, the priest (witch doctor) they always used, including on me on the wedding day. In the meantime, another local priest was brought in. No one even attempted to call a medical doctor, which I found not only strange but rather stupid too.

As this priest pulled his chair over to my husband, I couldn't help but think, *Oh God, what an idiot*, but before I knew what was happening, the priest's chair – with him sitting on it – rose up and flew across the room, throwing the priest against the

wall. I ran for my life; I'd never seen anything like that ever before. What was going on? Was I watching *The Exorcist* in real life?

I thought I was crazy and seeing things, but there was a whole house full of guests who saw the same event, so I couldn't have been crazy.

Other weird events happened after this, such as my husband getting up in his sleep, sitting up, tearing up his shirt with his teeth, and 'eating' it. Oh, not to mention the constant giant caterpillars that crawled up my bed and the snakes that slithered underneath it.

After these events, my husband, his mother, and his family told me that one of my other cousins – who'd planned to sabotage the wedding by kidnapping me – had done jadoo (black magic) on my husband, so that he'd die and my cousin could marry the 'Londoni Bride'. Others who sympathised with me, however, said that my husband had a 'dirty hand' in black magic in order to control me, given that I didn't want to marry him, and that he must be suffering from side effects. Who knows who was telling the truth, but one thing was for sure – I was being pulled from all sides because I was the Londoni Bride. No one actually cared that I was a person with a heart and soul; they just saw me as a valued materialistic item. Even my own parents were never there for me.

In normal circumstances I should have at least been able to turn to my mother, but no. No wonder I never really got on with her. What was the point in having a mother I couldn't confide in, especially when I was in distress? I was made to feel worthless, and I truly believed that no other man would ever marry me now, because – even if I left my husband – the stigma would always be with me.

My father left me after only ten days to return to the UK, leaving me to cope with married life – whatever that meant – alone. As soon as my father left, I was made to apply to the embassy for a visa for the new groom, even though my father had said not to apply for the visa until I returned to England.

The visa was refused on the basis of a bogus marriage; the British High Commission was suspicious because we'd only been married for ten days.

The FCO's Forced Marriage Unit wasn't around then, so there was no rescue mission for me – or any possibility of one. Now they can measure us with their statistics and their examples of the living dead – the victims of forced marriages, the 'nutcases' who don't even take our father's names. Most of us have the common meaningless surname of either Bibi or Begum.

Even in the UK in the twenty-first century, who cares about us, the Bibis and the Begums?

In the meantime, as the visa was refused for my new husband to enter the UK, he kept me trapped in Bangladesh. The only way to get a visa is to prove that the marriage is genuine, and the only way to prove this is to have a child. Because of this, I was trapped in the marriage; I could not leave him when I returned to the UK, and the visa would be highly likely to be granted. Effectively, he would kill two birds with one stone! So I was kept in Bangladesh, enduring marital rape every day until I was pregnant. I was kept like a prisoner and raped until I was pregnant, in order to prove that the relationship was genuine for the purpose of the visa.

## CHAPTER 5

# Life After The Wedding –
# Arrival in England

By the time I was about three or four months pregnant, I was allowed to go back to the UK. As I was pregnant, I had no choice but to stay with my so-called husband. I started the process of a fresh application while pregnant and working at my local GP surgery as a medical secretary, and I was still working when I had my first child – a son, who was looked after by my mother. I used to take a 15-minute break to go home, which was about five minutes' walk from work, just to breastfeed the baby. The visa was eventually granted and my husband arrived in the UK in November 1992.

The next 12 months went okay; he was the only son so his parents were his priority, which didn't bother me. I believed it was part of his duties. I continued going to work, leaving my son with my mother so that my husband could obtain his Leave to Remain in England; I was working part-time to support his Home Office application. My in-laws just seemed to ignore me and my baby, pretending to be ill whenever my husband had a day off from work – they seemed to be alright every other day. I was being neglected and totally ignored. In fact, my mother-in-law and father-in-law – my uncle and aunt, who were my own family members – told me to stay at my mother's house, saying it would be in my best interest to do so.

I had never cooked in my whole life – my father even made my breakfast for me – and before I got married, my uncle had

told my mother, "She's my niece, she does not need to cook. I am the chef, it's nothing she will learn. I am her uncle, I will teach her. It's nothing to worry about."

But I desperately wanted to cook for my family, so I'd go out and buy food, and would then ask my uncle what I should do with it. He'd just shrug and say, "Oh, just cook it how you like, it's nothing. It will be okay, it's only us, just do your best." So that was all the help I got from my father-in-law, who'd promised his sister it was nothing to worry about. Little did I know that he was insulting me, making fun of the way I cooked. He would tell my mother how I chopped up ginger and put it in fish curry, even though it was only meant for meat curries. After insulting my cooking in a passive aggressive way to others – especially to my family – he would always finish off with, "But it tasted very nice."

It seemed I couldn't even 'tiptoe' in the house without the information being passed on to my parents. My husband had started work at a restaurant straight after he arrived in the UK, but neither I nor my son had received a single penny in maintenance while we were living with them. Clearly, my baby and I were burdens, and my in-laws wanted to get rid of us. My husband gave all his money to his father, who in return gave him only £5 for a whole week of expenses. He also complained about his 14-month-old grandson (their only grandchild) drinking too much juice, which he said was costing him too much – a packet of juice was about 60 pence. He said that his son's money wasn't enough to cover the expenses, meaning I should give my money to him as well.

I was only working part-time and I needed money for my own expenses, as well as for my child, who they were refusing to provide for at all. I tried everything in my power to please my in-laws so that I could be part of the family, but nothing I did was ever good enough for them, especially after my husband was granted permanent settlement in the UK. I was never going to be good enough for them, or for their precious son, and they were going to make sure of that. It seemed they'd already

chosen another bride for their son – my mother-in-law's niece, who'd already been brought over to live in their village. My in-laws were igniting all sorts of trouble in order to pursue a plot for divorce, as now their son could afford to marry another traditional village girl from Bangladesh and increase our family's population in England. This is immigration through the back door, which is still being practised even to this day.

Due to the horrible treatment I had to endure, I ended up being sectioned in a mental institution (at The Faringdon Wing, part of Luton & Dunstable hospital) after a suicide attempt – though it certainly wasn't my first. I was only let out of the mental institution because my doctor – who was also my employer – appealed against it, saying I wasn't mad but that my husband and my in-laws were driving me insane. He requested my release, which was granted, and I was put on several antidepressants and sleeping pills, mostly Diazepam and Seroxat. I would live on this cocktail of drugs for a long time.

Eventually, my father bought me a separate house and my husband decided to join me. Little did I know that his desire to live with me was just a plot to get a British passport – he needed to have my permission in order to apply. I only found out when he left me, though he came back again two weeks later, falling at my feet and apologising for leaving. I forgave him and took him back.

A week later he came home from work all distressed, saying he'd made a mistake and that he didn't know how to get out of the mess he'd got himself into. When I asked what he meant, he said that the night he'd come back, he'd stolen my British passport to send to the Home Office, in support of his own application. The Home Office believed he'd stolen the passport, and were consequently sending an immigration officer from Luton Airport to interview me, to get my consent. If he was found to have stolen my passport then he'd be deported back to Bangladesh and jailed for 14 years. As he spoke, his tears fell like the monsoon rain of Bangladesh. Being the emotional type, I fell for his act – and the 'monsoon rain' – and forgave

him, and when the officer came I told them I'd given him permission to send in my passport with his application. They believed me, and he was issued with a British passport. So, he'd only come back to steal my British passport so that he could secure a better status here in the UK, yet again at my expense.

As a result of moving to my own house I regained some of my self-esteem and started a course at Luton University (now called Bedfordshire University). At the same time, I was promoted at work to senior medical secretary. I also worked at home assembling car parts, as well as going to Aylesbury College in the evening to pursue an import/export training course.

Everyone thought I was mentally ill because I worked full-time at the surgery, then at night assembling car parts, as well as attending university and doing a college course. I also learnt to drive so that I could drive myself the 40 miles out of town to college and back, finishing college at 9 p.m. It was particularly hard in severe winter weather, while also bringing up a baby at the same time – not to mention all the other domestic chores I had to keep on top of.

Even though it was incredibly hard, I had a passion to succeed and to better my life. When I passed my driving test in 1994, I was the first driver in the entire family. I also saved up some money and got an engineer to build me a computer at a cost of about £800. This was back in 1994, when modern technology wasn't as readily available as it is now, so things were expensive.

I was always searching to do things for my personal development, so I undertook many things and many jobs at the same time – and besides, they were necessary; I needed money to pay the mortgage, bills, my college and university course fees, and so I could buy food for my baby. Whatever happened, I was determined to succeed. I think my mother felt guilty about what happened to me so she offered to look after my baby, for which I was grateful.

As my husband and in-laws were now seeing a successful woman and not the desperate housewife they were used to,

they got very upset; it seemed none of them could cope with my success, especially the money I was earning from two jobs – money I wasn't giving to them or to their son.

This, of course, caused more frustration and anger, and even my husband started to demand money instead of providing for me. As it now appears, it was always to do with the money; my in-laws wanted me to work, but they also wanted me to give them cash. They'd put the burden on me to maintain their son before he arrived in the UK, at a time when he was going through some village disputes. So, I paid for his court cases, I paid for his application, and I even paid off his loans, which had been taken from my father to fight his village politics and disputes. I find it funny that the same village men who were causing conflicts back in 1989–1990 were the same people causing similar conflicts against me in 2007–2009.

These were also the same men I had to pay to defend my husband against the man who wanted to open the path through my asset for public use, which was in dispute – even though he was the one who about 20 years earlier had closed off the public path to the local villagers, who tried but failed to fight against him. So, it felt natural to tell him to open the original path he'd blocked 20 years before, rather than asking me to open a public access through my own asset. After that, he never set foot in the so-called 'village court' again.

Even when I was living in my own house – the one my father had bought for me – my in-laws were constantly interfering in the marriage and asking for money, even though I asked my husband to meet all of their needs. I refused to give them any of my earnings, so my husband demanded that I stop working. He also insisted that I should no longer go to university or college. At the beginning, I gave in to his demands for the sake of peace and for my son, but later – in secret – I tried to continue with my studies. I hid my college and university work inside the bed base under the mattress, where I'd cut a hole just big enough to put my books and stationery in, and I attended college when he was at work.

It worked for a while, but one day he came home late at night to find me still awake. We had an argument and he punched me senseless in the eye several times. I was in unbearable pain; I could feel my eye and one side of my face swelling up within a minute of being punched.

The emergency services were called and the ambulance and police came at the same time. Then, while I was taken to hospital, he was arrested and taken into custody.

When I was released from hospital I was taken to my parents' house, where police officers came to take a statement from me. While I'd been in hospital, however, a whole gang of community leaders – mainly men – had gone round to put pressure on my parents. They wanted them to get me to drop the charges, stating it was a community matter rather than a police one. Outsiders, they said, should not be involved in community affairs.

While I was talking to the police in another room, some of them even came in with my father, telling me in the Bangla language not to go ahead with the statement – they would sort it out themselves.

I looked at the police, who could sense my fear, but the police officer just kept saying, "Don't listen to them; your husband will only do it again." More and more men surrounded us, and I felt very scared and intimidated – so much so, in fact, that I didn't continue giving the statement to the police, and my husband was released. The community leaders involved didn't do anything to help; they just told my husband not to do it again and pressured me to take him back. Which I did, yet again.

My eye took one year to recover, and even to this day my left eye is smaller than my right.

I knew this was a marriage made in hell, and I also knew that if I didn't get out, I would commit suicide. My mother's promise of, "He's my own, I can slap him if he hurts you!" before the marriage was never acted on; instead, I was declared a bad wife. I was still a teenager, yet I had a baby of my own,

and I was being neglected and abused. I was just hurting so much inside. I had no one to really turn to for help, and I was so desperate for someone to just love me and hold me tight.

I'd gone from this innocent young girl, to a young mother, to a bad girl. Why?

# CHAPTER 6

# The 'Bad Girl'

My husband kept coming and going as and when he liked – and I was made to take him back every single time – but around September 1998 I finally decided enough was enough. I wasn't going to be bullied and made to feel isolated and neglected, not to mention being called a 'bad wife'. If I was going to be bad, then I should just be bad. If I did this, surely it wouldn't hurt when people called me a bad wife – which was what everyone in the community said about me anyway. In a community like Luton, however, people target the girls who have clean reputable records, so even if I was good, the majority would have nothing better to do than gossip anyway. One of my neighbours actually heard that my main problem was that my husband wanted another child and that I'd refused his demand. Although it was true, it certainly wasn't the only problem we had – not that it was any of their business.

My neighbour suggested I should comply with his demand; she was adamant that if I did, he would magically turn into a good husband. I knew, however, that this woman had always been envious of me, so I told her, "Well, you're good at having kids, why don't you keep your back door open tonight? I'll send my husband over. Have a kid for him yourself!" She didn't like that, but I've found this is the best way to rise above the gossips in my community.

It was exactly the same as the village politics in Bangladesh; uneducated people who lived on public funds had nothing better to do than gossip about me, which of course was spread around by my mother-in-law and father-in-law.

I decided to go for a crazy new look, so I cut my hair and dyed it yellow – I wanted it brown, but as I'd bleached it before, the brown turned yellow – and I also got myself a sports car (my beloved Mazda 323, the same style as the famous *Knight Rider* car, but in white) and an executive job. I also took a couple of martial arts classes, to prepare myself for the next time! The girl who always respected family honour, and who never even went out other than to school or work, had now become something that no family member could have ever imagined. From an innocent teenager who always thought of family and honour, I had now transformed myself into a 'bad girl'.

That is exactly what I became. I was ruthless and dangerous, and when my husband tried to hit me again for some minor arguments, I didn't just sit there and take it. The next time he tried to hit me (in September 1998), he said, "I didn't do a good job last time but I'll finish it off now," as he grabbed my hair and aimed the punch at the same eye. But I was prepared; my hair was now very short – so short that he couldn't get a grip on it like he used to do – and my martial arts classes had given me confidence. Before he could hit me, however, I got the stool that I'd made in school – luckily it was within my reach – and with all my strength I threw it at his head, causing blood to pour out and splatter everywhere. I felt very satisfied, and I still feel satisfied about it even to this day.

I don't think I would have cared if he'd died as a result, or if I'd ended up in prison. It was as if I'd turned into a very focused and calm psychotic woman who'd simply had enough!

But it didn't end there. Next I called my brothers, who came over and gave him a few more punches. With five brothers behind me, I felt very powerful – as though I had my own army – and with that, I damn well kicked my husband out of the house. I felt no regret and no fear of what would happen to me, though I made sure that nothing would happen to my brothers; I'd take all the blame.

My husband had me arrested in the early hours of the day, filed for a court case, and tried to have me raped by hiring

a group of gangsters (as he clearly wasn't man enough himself); but by the grace of almighty Allah, I managed to drag him outside of his own house and kick him. By that time people had started coming out onto the street, so the group of men quickly left the scene.

I had become someone I didn't know. I had become someone who didn't care about life. I was ready to die, so all I had in my head was, "If I'm going to live, I'm going to live properly."

Every time he had me arrested, I got violent. I broke his car in broad daylight and in public view, not caring who saw. The people who were watching this violence were the same people who gossiped about me and insulted me behind my back, so I was intrigued to see what they'd do. *If you want to gossip, then gossip properly*, I'd think.

When my husband filed a court case against me, making false allegations about how I wouldn't let him see his son, I chased him in my car – which he called 'hijacking him' – along a busy dual carriageway, passing Luton Police Station and going all the way to Dunstable, towards his workplace in Aylesbury. I demanded he pay money for the maintenance of his child, and I have to admit, it was a moment of madness; I stopped other traffic while demanding the money from him.

He was scared as I swung the baseball bat, and while at first he gave me £20, I demanded more. Then he gave me around £100, which I thought would be alright for now. I'd also started smoking and drinking.

I'd been a naive teenager, hoping to set up a family with my husband and his family. Even though I was forced to marry him, I forgave him, hoping that the marriage might work out. But they had killed an innocent teenager, and now she'd become a desperate fighter – a fighter who had no control over what she said or did. Who was responsible for that? I wasn't born to be a rebel; I was forced to become one.

# CHAPTER 7

# Marriage Ends

I fought my own court cases – including the various criminal cases that had been brought against me – and won them all. Then, finally, and against the wishes of the family and the community, I filed for divorce.

I can remember how, despite all the allegations, on his final verdict the judge said to my husband, "The next time I see you in my court I will throw you out. Not only did you come here depending on this poor young woman, but you have been living here for over eight years and you come to my courtroom with no knowledge of the English language, using interpreters at the public's expense. Get out!"

I was even backed by the Sharia Court of the UK, which deported Omar Bakri Mohammed from the banned Al-Mujaharon, criticising him for not paying any maintenance to his wife and son while still demanding that his wife obey him.

The Sharia Court of the UK further highlighted the extreme responsibilities of a Muslim husband, something he'd very much failed at. They also stated that if he was in an Islamic country like Saudi Arabia, he would have suffered severe legal punishment. Ultimately, they pronounced my divorce decree on the basis of the Shariah Law, which they stated as being the 'khulu'.

It was a success, which I was very happy with, and in 1998 I went on holiday to Bangladesh with my family for a much-needed break.

I was now working as an account executive for an importer in Harpenden, and as my success grew, so did my confidence.

# CHAPTER 8

# The New Beginning of the New Marriage – to my Second Husband

While in Bangladesh I met another cousin, who was also the first cousin of my ex-husband. To make matters worse, I fell in love with him. Well, I don't know whether it was love exactly, but I was single again, and it isn't culturally acceptable in Bangladesh to be single – plus, divorced women are degraded so much that they're seen as a 'curse' or described as 'untouchable'. And so the pressure of marrying was on me once again; I was still under the control of 'you cannot be single'.

Even though I was building my self-confidence, and even though I could have said no to this second marriage, I just couldn't; there was still some sort of dark cloud hovering over me, a hold over my mental state. Basically, I was still scared of not adhering to the cultural norms. I was free, but not mentally free.

There was still that mental barrier I just couldn't cross; I was still fighting an invisible cultural fear, one that perhaps every female has embedded in them from the day they're born.

It's very difficult for someone who isn't from my culture to understand why I did this again, and to be honest, even I don't know why I did it.

## My Asian Muslim Cultural Norm:

In my culture, when a girl is born she is groomed from an early age to obey men and to keep the family honour.

As women and girls we have to follow 'prehistoric' cultural rules, and to dishonour the family's reputation often means being cast out, shunned, and disowned by the family – and all too often, dishonouring the family could mean death!

For us Asian Muslim girls, what we can say, who we can say it to, who we can have as friends, where we can go, what we can wear, how we can have our hair, whether we can put make-up on or not, and who we can marry, is all decided for us – even here in the UK, and especially when growing up in the '80s and '90s.

## Culture, its importance, and its impact on Asian Muslim women:

Culture can be described as patterns of behaviour, customs, values, attitudes, and important rules of conduct such as taboos and sanctions, which are shared with others who have the same country of origin, even if they move – the culture is likely to be preserved wherever they go.

An Asian family can be extended over a number of households; it is more like a 'clan', which is a fundamental part of their foundation, providing many different types of support and emotional security. As a family they are judged as a whole, so independence and privacy within the family unit is not acceptable – it is regarded as breaking away from the clan system or away from a person's cultural obligations.

Gender stereotypes are also important in the Asian Muslim culture, as men are regarded as superior while women are held responsible for maintaining the so-called family honour – or izzat – as well as making sure they avoid bringing shame to the family (sharam). Often, in the family's words, women and

girls are 'guarded or protected' as they aren't regarded as being an individual but instead are seen as property. So, a woman is either the property of her father or her brother, and then when she's married off, she becomes the property of her husband, and so on. Her entire life is decided by how the man 'in charge' of her sets the rules for her daily life.

## Why cultural pressures affect women:

Girls are groomed from the moment they're born, making it impossible to challenge male authority. A woman is taught how to be a good daughter, a good wife, a good mother, and a perfect daughter-in-law. They are taught how to cope with bad family members and situations, and are told not to take their problems outside the home, as it's regarded as taboo to talk about home problems with strangers. Girls are taught that men are superior – especially their husband – and that *their heaven lies under the feet of their husband*, hence he has every right to beat her. The old women's teachings are that 'a good wife is a wife who can put up with a bad husband,' therefore women often lack support from their own family as well.

While in some sense culture is important and provides a way of life and an identity, it also has the power to harm people – especially women.

For the reasons I mentioned above, it was tough for me to free myself from the mental hold of the cultural norm, so I decided to marry again and hope for the best – which, unfortunately, was the biggest mistake of my life. Perhaps I was more vulnerable and emotional having being groomed to obey all my life, but I felt sorry for his family – especially his mother – as well as believing I was still young and attractive and would therefore get married sooner or later again anyway.

I thought that due to the stigma of my previous marriage, proposals would only come for the visa, not for me, and I thought that if I married this man, at least he wouldn't neglect

my son – considering my son was his nephew. If anything, my son would not lose his status as he would still be from the same village. If I married an outsider, my son would be called an 'outcast', or in Sylheti, 'boi-thol'.

Even though I was an executive with a high-flying career, and an international businesswoman with many highly educated suitors in the Western world – where divorce or children weren't really issues when it came to remarrying – I wanted to be married to a Bangladeshi man. A man who truly loved Bangladesh, and whom I could eventually live with in Bangladesh in a traditional 'jamidari' culture, like the one I'd left when I was a child. I envisioned everyone united and living together, enjoying the culture and the tradition.

I hoped that my children would have the same upbringing of family unity, with the culture, the tradition, and the Islamic religion.

This man promised me the 'bagan, moi-na phaki,' (the beautiful garden with mayna birds, morning sunrise, evening sunset') and told me I was going to be the 'Jamidar-er bow' (the wife of the wealthy land owner), with my mother-in-law being the head of the family. He also told me how I was going to build a villa and name the villa after my mother-in-law, calling it 'Sayarun Villa'. How stupid and naive was I to believe in all these fairy tale love stories?!

I thought that if I married him, and if I gave him – and his mother and sisters – the opportunity to have a better life, they would appreciate me and we could build a life back in our home country as the wealthy land owners, with all our cultures and traditions.

Of course his mother approved the marriage, though my parents didn't have a say; as they'd made such a mistake with my first marriage, naturally their say would not have gained any approval by me.

# CHAPTER 9

# Life After Marriage to my Second Husband – 'The Living Hell'

As I worked as an executive for a successful company, my boss helped to sponsor my new husband, so the visa was no problem; my second husband gained entry to the UK on a fiancé visa and then gained the right to settle permanently.

Before I married him, I discussed the cultural norms with him at length, telling him I wasn't going to follow all of them. I specifically told him that I wasn't going to be forced to wear a burka, and that I wanted to have my own freedom to work – he knew my career was important to me – as well as freedom to see friends occasionally. Furthermore, I told him that if he was going to marry me, he'd have to adapt to and respect certain ways of the UK.

Apparently, this wasn't an issue for him. In fact, his words were, "Well, I'm following you to your country, therefore I need to respect your wishes. And your requests are very reasonable; why should I have any issues? I have no problem with any of it." He then went on to say, "I am lucky to have a woman with a career; not many men are lucky to have a woman who is good looking and successful."

There were things I was happy with, such as accepting his mother and siblings as part of my family, and I knew that he might have to support them as well as supporting his own family with his earnings. However, the moment he entered the UK, I was put in isolation. I was not allowed to talk to

anyone or go out to work. This was the worst situation I had ever known. But then he wanted money all the time, and his brother and his friends were on the phone every day, asking for money to pay their debts, so I went back to work. I gave them money, and I kept on giving in to their demands. It seemed the 'bloodsucking vampires' had suddenly been released from their graves. I gave and I gave, and I suppose it was because I wanted to give in order to make them happy – I wanted them to love me.

But before long the demands started coming more and more frequently, this time for their mum and their sisters (one of which had about 14 children). Every month I gave them around 20,000 taka in money, as well as buying household items to make the sister's life more comfortable, then for the grandmother, then for the uncle. It seemed the family was increasing at a rapid rate as I gave them support and money from London. These demands started before my husband had even looked for a job of his own.

These were the people who'd been begging for food, but now I was giving them between 50,000 and 150,000 taka a month, and it still wasn't enough. I was giving money and supporting the family without complaining whatsoever, but then the violence started. I was punched for no apparent reason. He would call me at work, and if I was busy, I would be kicked and punched when I came home.

He would accompany me to work and just sit in the office waiting for me to finish, which was very embarrassing for me in front of my employers. Then he ordered me to leave my job as an account executive (when I was on a £35,000 annual salary) to work in a shoe shop in Bury Park in Luton, for just £80 a week. I was forced to leave work, but when I did I was beaten up every day for having no money. My son was subjected to most of this abuse too.

I even almost died in a car crash as a result of my husband shouting on the phone while I was driving back from work – and I'd had to leave work early because he kept calling me every

five minutes for no reason, asking me all kinds of questions. I was called names such as 'besha' (meaning 'prostitute'), and he said that I'd burnt all my internal organs as a result of having sex with many men before I married him; otherwise I would have been pregnant by now (he had only been in the UK for around two or three months at this point). He said that people were embarrassing him because I was a divorcee, which was made worse by the fact that I wasn't pregnant yet.

Fortunately I did become pregnant shortly afterwards, and in October 2002 I had a baby girl. He didn't help, of course; he wouldn't even go out to get a bottle to feed her. I was assaulted and shouted at because of his tiredness from staying awake in hospital while I was having the baby. I ended up having to call my mother to get the things I needed for my girl as I was too ill to go out myself. Unfortunately, assaults on women – including marital rape, which isn't regarded as rape in my culture – continue to happen every day.

In the Asian Muslim culture, the wife is forbidden to say 'no' to her husband if he wants sex; it is the obligatory duty of a wife to allow her husband to have sex as and when he wants. If a husband forces his wife to have sex it is not regarded or accepted as rape within my cultural practices, as the wife is always to obey her husband.

Not long after, I became pregnant again, and when I was eight months gone I had to travel to Bangladesh for my cousin's wedding. I went to my husband's village, and even though my husband had a houseful of people, not one single person woke up at night when I called out to them to heat up some water to make milk for my baby. I struggled in the kitchen, trying to light the firewood, but I failed. My husband started shouting and abusing me instead, threatening to hit us if my baby didn't 'shut up'. I put her to sleep without any food and moved out of the room in order to avoid being beaten up – especially as I was heavily pregnant and in his village, on his turf. I was treated like an item by this man and by his family, all of whom were entirely dependent on me. All they wanted was my money.

To make matters worse, on the 4th of January 2004 I had my second daughter, while still in Bangladesh. It was another girl, which of course disappointed his entire family, and especially his mother. Her first words upon seeing my baby were, "Why didn't you come with a willy?" My husband didn't care about the fact that I had a newborn baby, as well as a 12-month-old baby in my arms – he was ready to kill us if I complained about being left alone without food.

I couldn't even get him to arrange a passport-sized photo to be taken of the baby so that I could get the passport made at the British High Commission. He wasn't even capable of doing this small thing, which of course led to more verbal and physical abuse. There were constant demands of money, money, money; the brother needed mullah, kobi raz (exorcists), as apparently their stepmother and her sister had done jadoo (black magic) on him because there was no one to look after him now that their mother was in England. I helped her and her daughter to obtain the visas to come to the UK.

Also, it emerged that their brother was having an affair with a 12-year-old servant girl who was living there with her family of 10 or 12 people. He was sleeping with this minor, but according to my husband, his mother, and his sisters, it wasn't his fault – even though he was a 38-year-old man at the time (back in 2004). No, it was not his fault because their stepmother and her sister did a 'jadoo' on him, making him have this affair with a 12-year-old girl. He was totally innocent – "my poor child," according to his mum. What's worse is that 'Zinna Mumin' (the spirit of the dead) now said he had to marry this minor or else his legs would be broken… or so I was told.

Despite all the drama in this primitive marriage of hell I'd been cursed with, I studied day and night for three months – without sleep, and with two babies – and I became an officially registered immigration advisor. Only my god knows how I managed to pass this with the Office of Immigration Services Commissioner (OISC) at the highest level to practice (level 3). The only person witnessing my study was my uncle – my father's brother – who stayed with me during his visits to

the UK as he didn't want to stay in his brother's house, even though there was plenty of room. Apparently he was scared of his older brother, though why, I have no idea.

When I received my licence to practice immigration law I started my own business, which immediately started to flourish, having successful cases from people of all backgrounds. Some might find it confusing why I worked, instead of giving the responsibility to my husband – especially as he made me leave my executive job with a company car, pension, bonuses, and many other privileges for being a top employee – but the simple fact was that he just wasn't capable of working. When the bills needed paying and I mentioned this to him, I'd receive a barrage of verbal or physical abuse if I didn't sort it out myself.

He never stayed long at a job. If he did go to work, he'd come home and abuse me for not warning him how hard the restaurant job would be. He'd say I was a heartless and evil woman for letting him work in a restaurant, even though he wasn't capable of anything else as he didn't speak any English. I even chased around colleges for ten months, trying to enrol him on English courses.

After ten months, when he was finally given a place at college, he refused to go, and when I mentioned how hard I'd worked to enrol him on the course he called me names, slapped me, and hit me with the files I'd bought for his studies. Nevertheless, he would never stay at a job for long and would always blame me for being a 'cursed wife' – or in Bangla Sylheti, 'olokki'. For these reasons, I had to make my own provisions for financial means. So I contacted Wing Lee, my previous employer, who offered me my job back but on a part-time basis, with a company car (a BMW Mini Cooper), company mobile, and laptop so I could work from home to fit around my babies. However, just like before, my husband made me leave this job because it gave me recognition and status. I had to think of something else in order to financially manage my family, so I set up my own business, UK Group Ltd. There were two separate divisions, one dealing with legal services and the other dealing with supplies for the restaurant trade.

I employed about ten staff including delivery drivers, administrators, accountants, and bookkeepers, and after just my first year of business the estimated turnover was almost half a million, as my accountant confirmed. I owned residential and commercial properties – two houses, a two-bedroom flat, and a warehouse with a large freezer room – plus a freezer lorry and freezer van, all with estimated values of circa £800,000. I was a successful businesswoman earning around £500 a day, even up to £6,000 a day, but I didn't have my own life. I earned money but I didn't see any of it. Money used to be extorted from me by my husband's threats and by force, even money that was needed to buy supplies for the business. He didn't care where the supplies came from, as long as he got the money himself for his own purposes – whatever they were.

On the other hand, if the supplies weren't bought then I'd be beaten up. He would take money from the business for himself, forcing me to get supplies on credit or to pay for the supplies from the UK Legal Services profits. However, if I refused to do this because I knew he wouldn't pay them back, I'd be beaten up as well. There was no way I could ever win.

Eventually I became suicidal, trying to manage two fast-growing businesses as well as the home and my family. Despite the business bringing in a lot of money I was still struggling, as I didn't have any money myself given that the 'exchequer' was my husband. I only had to earn, not have my own money. I also cooked pots of food but I had no time to eat it myself; I had to settle for my daughters' leftover bits of food, which they passed to me from the back of the car when I collected them from nursery. It became routine for my daughters to leave bits in their lunch boxes for 'Mummy'.

I was getting desperate, wanting to break free from this cycle of abuse. The only way out as I saw it was to kill myself, but what was I going to do with my daughters? Even though I was a successful businesswoman with many assets, I needed to survive. I needed to escape – otherwise, I really would have to kill myself.

# CHAPTER 10

# The Escape to Rising Success

Then, luckily, I received a call from my previous boss at the export company I'd worked for, who was now working for another company that had a venture going in Bangladesh – one he wanted me to manage. As I was desperate to escape, I took this offer immediately, travelling there in March 2007. My husband actually agreed with me taking the job; as it was Bangladesh, and as I was a British person raised in the UK, he believed he would be in charge.

When we went to Bangladesh, my company paid for all of my expenses as well as my salary for the inspections and audits I was now doing for them. My main role was Operations Director, though I was also the Inspector Auditor & OISC Immigration Advisor.

Between 2007 and 2009 I helped export circa US$15 million worth of goods out of Bangladesh on behalf of Diageo (4CX in London), as well as doing all my Immigration Advisory work. I even broke a record for arranging payment by TT of US$150,000: this had never before happened in Bangladesh's banking history, as I was advised by my executive at the factory. However, at the time I didn't know about this. My boss seemed to trust me so much that he asked me if I trusted this supplier, Amazon Textile, who was dealing with a large order for us. I advised that I did trust them, and upon my word the large TT was arranged.

I was also the only Bangladeshi – or British Bangladeshi – to be authorised to conduct audits in Bangladesh. I managed all exports in South East Asia, as well as conducting all audits

and inspections. The projects I handled included: the Guinness Africa Nations Cup in 2007 (which the large TT came in for) during Cyclone Sidr, where I exported to ten African countries, Euro Cup 2008 (Guinness, exported to six European countries), and Cancer Research (pink t-shirts in 2009), to name just a few. As well as garments out of Bangladesh, I also handled exports of footballs out of India and Pakistan.

I was being treated like a VIP, attending meetings and dinners with government officials – such as former British High Commissioner Anwar Choudhury and other diplomatic officials – both in the UK and in Bangladesh.

However, success and my status were now causing conflict in my marriage, and my husband started demanding that I stay in the 'basha' (house) while he brought immigration contracts over. Basically, this meant he was getting involved with people trafficking, where he would charge people five lakhs for applying for tourist visas, and up to 10 lakhs for other visas (which is in the region of five to ten thousand pounds). He also told me I was not to work for 4CX anymore, work in International Trade, or work as a Legal Representative according to my licensing authority, OISC, which was clearly giving me recognition in Bangladesh. So, basically, I just had to stay in the house and do as I was told in relation to people trafficking.

He accused me of shamelessly advertising myself in front of men just because he didn't approve of my smile, and he'd accompany me to every meeting and every inspection, where he'd do absolutely nothing. He'd just watch, shake his knees, and pick his nose out of boredom. I didn't understand what my smile had caused in those meetings – other than many people telling him how great his wife was. I never understood why my smile was so deadly for him. Furthermore, he would also watch what I wrote in my emails, even though most of my correspondence was to do with my work and business as I didn't have time for friends, family, or even my children.

Not that I had much choice; he'd make sure I didn't communicate with any friends or family anyway. He had no

education, but he could pick up certain words, and if he didn't understand it he would question me suspiciously, keeping on at me until it drove me crazy.

He'd just sit there and watch me type, no matter what time it was; even if I was working in the middle of the night, he'd refuse to go to sleep, or if he did it would be on the sofa next to me. Not only this, but I couldn't even go to the toilet alone because he'd follow me in there, and I could never lock the door because he'd get angry if I did. He'd just stand there and watch while I was in the bathroom.

When he was in Bangladesh with me – especially at the beginning – he would make me hire private vehicles (that cost me up to 6000–12,000) even when I protested, saying it wasn't fair on the company because they only paid for my expenses as an employee. He said to claim the extra by saying he works for me, which I refused to do because it would be dishonest, especially to my boss who always had faith in me as an honest and trustworthy employee.

I wasn't going to betray his trust, so I just paid the extra out of my own pocket, hoping it would give me some peace and quiet – which, of course, it didn't. My husband made me hire this 'LiteAce' microvan so that he could transport his entire uneducated fleet of village scrounger family members, who also accompanied me to the factory every time I went. Even though I allowed him and his entire family to bodyguard me everywhere I travelled for work in Bangladesh, which cost me a fortune, he still managed to force me out of a meeting with the factory managers after 15 minutes of arriving in Narayanganj. It was utterly embarrassing, particularly as this was my first official meeting with the senior management and the owners of the Amazon Textiles factory, not to mention their co-partners and the executive dealing with our orders at the factory.

We left Sylhet at about 4 a.m. in order to reach the factory on the outskirts of Dhaka, Narayanganj for 12 p.m., but instead we got there around 2 p.m. The factory management had arranged for lunch before we started the meeting in the

boardroom, which consisted of seven senior members of factory staff and myself on behalf of 4CX UK – plus, of course, my 'village bodyguards' who were watching my every move. This included my husband, his uncle, and two of his friends, none of them having even the slightest hint of any education, let alone any business sense.

Within 15 minutes of arriving – and after lunch had been ordered for us from the local takeaway – suddenly, in front of everyone, my husband demanded that I leave. Why? There was no reason, I just had to leave! Everyone was so shocked and none of them could understand what was happening. He just kept saying, "Get up, we're going."

He had no respect whatsoever for my work or my honour.

I only found out from his friend during the journey back why he wanted to leave: I'd laughed at a joke the executive had told, and – even though it wasn't loud and no one else noticed – my husband didn't like it, so apparently it was my own fault for ruining this important meeting. What a waste of time and money.

His whole intention was for me to sit in the house while he made contracts with people for UK visas. I wasn't to do anything other than deal with the applications for his people trafficking deals that he and his family would arrange, and I wasn't to talk about fees or costs as they would deal with all that. I was aware, though, that he'd be charging a minimum of £10,000 for a successful visit visa application, which I found to be extortionate.

Despite his attempt to ruin my career even in Bangladesh, I refused to be forced into something as appalling as people trafficking or illegal trade. I told him, therefore, that I was an educated professional and would only work according to my code of conduct. I was not a 'dalal' (illegal agent) and I would not take money that is 'harram' or illegal – I have to sleep at night, and even if I didn't suffer now, my children would ultimately suffer the consequences of my misdeeds. I wasn't prepared to do this, even if that meant he had to kill me. I'd rather live on legitimate money of £10 than illegitimate money of £1,000.

I was also ordered to pay 10,000 taka (circa £100 UK sterling) a month to him for his brother in the village, or pay him a lump sum of 4 lakhs taka (about £4,000). As I'd had enough of giving him money over the years, however, I refused, telling him that I'd given him all the agriculture equipment he needed and that it was time he told his brother to work. Furthermore, my husband wanted to marry his 14-year-old cousin, and he wanted my permission for this second marriage.

I refused all his demands. I was scared and I knew there'd be harsh consequences, but I could only cope with so much. I had to take a stand now and say *no*, which is exactly what I did. Loud and clear, I refused, telling him that if he wanted to marry his 'Teenage Tart' then he'd have to divorce me first.

I refused to feed yet another burden from hell. He and his entire family lived off me, clearing debts from before he'd even married me, and now he had the nerve to bring another addition into his already 'bloodsucking vampire' family from hell, another person who would live entirely off me and my earnings.

When I'd previously visited this family together with my husband and my children, this girl had been joking with me as a sister-in-law, as she was my husband's so-called cousin. Her mother had been so nice to me, asking for immigration advice on UK visas for her son and for a relative who had a wife in the UK but who wanted to marry in Bangladesh. Of course, I later found out that the family's relative was my own husband; at the time I had no clue they were seeking this immigration advice for my own husband and their teenage daughter!

When I refused to give my husband permission for his marriage to the 'Teenage Tart', he picked up a big piece of bamboo and – not for the first time – threw my computer off the table before hitting me so badly that my sister-in-law (my cousin's wife) and my 13-year-old babysitter started crying in fear and shock. My husband was beating me as if I were some sort of animal he was trying to kill.

When I think about it now I hate myself so much for staying with this animal of a man, this beast, who had no qualms at all

about beating me up for not fulfilling his demands and not providing him with money, expensive clothes, and other items.

My cousin's wife tried to stop him but failed, and as my babysitter ran to get help and call my Dada (my grandfather – my father's uncle), my husband ran her down and started beating her with the bamboo. My Dada came up and also fought to stop my husband, who by now had come back and had started hitting me again, in front of my two daughters. Both my Dada and my cousin's wife held on to the thick bamboo pole and were swung across the room as they tried to stop him. I was worried about my Dada as he had a bad heart, and in the end I was left with visible bruises all over my body.

I complained to his uncle, his mother, and his brother, together with my Dada, and although his uncle and brother told him off, they were grinning while they did it. His mum – my 'wonderful' mother-in-law, whom I'd felt sorry for and who'd sacrificed my life for her and her children's wellbeing – had nothing to say other than, "Oh, he is a 'bebat'," meaning 'he is a naughty boy.' That's all – a 'naughty boy'. Now that I was refusing to provide money the way I used to, my abuse was something that was funny and appealing to them.

# CHAPTER 11

# My Battle with the Past and Present – 'The Lady Still Stands'

At the same time my ex-husband and his mother had taken the opportunity to harass me, and had filed a number of court cases in Bangladesh by paying bribes to police officers and petty village criminals. This was just to settle the difference he was unable to settle in the UK. He'd filed a number of allegations – about four or five, including land disputes and corruptions – at the police stations and courts in Sylhet. The hired goons – one of which was the 'Squatter', as I called him – barred me from getting to my assets, which had originally been sold to me by his mother at the time of my marriage, as mentioned earlier.

Village 'dogs' (as I called them) had been hired to attack me and my son if we attempted to step onto our own land. However, I went anyway, and so did my son, along with a cousin. The moment we neared the village I could hear men; there were voices coming from the other side of the gate, probably men hired from the three local villages.

What followed next was beyond belief. I wasn't prepared for anything like it, but the intimidation by these men only encouraged me to fight, and to keep fighting until the fight was done. You can read the full story in the Extracts of My Life chapter under 'British Bandit Queen'.

I suppose this defiance was my way of letting those men know I wasn't the same woman or the same little girl they'd once known and abused. I had changed. Now, I was strong. I wanted

to take them on to show them I wouldn't be defeated, despite them knowing that I'd been bought 20 years earlier so a man could gain entry to the UK. I was different now and I simply would not let them win. This was a fight for my honour and for my self-respect, a fight I must win at all costs.

My mother-in-law had taken out every deed they had in order to buy me and speed up the marriage, and now – after 20 years – I wasn't even allowed on my own property, which had been legally purchased by my father and put in my name. Not to mention my son, who was the rightful heir to the whole property, according to Bangladeshi customs. If they hadn't filed any court cases against me for these lands, I probably wouldn't have bothered and would have just let them have it, but they provoked me into pursuing the matter, and I was determined to fight so I could win my honour as a woman.

Not only was I dressed in jeans and a shirt in a remote village in Bangladesh, but now I was determined to fight with about 200 men – the 'village dogs'. My intention was not to fail – if anything, it was going to be a war and I was going to get the British Bangladesh government and media involved. I wasn't going to run. I wasn't going to leave without making a scene that would be reported in international media and politics.

The police weren't bothered enough to come out, since they saw this as an opportunity to get more bribes. I called them, though, and eventually – when they realised I was no ordinary Londoni woman, and that no matter what, I wasn't going to be defeated by them – they came out.

For the next year or so I was harassed in every way possible – in fact, I'd even use the term 'terrorised'. I was extremely busy with export orders from my company, but now I was also fighting a number of criminal charges against me. The police were so corrupt, taking advantage of the situation and helping to escalate it even more so that they'd get more bribes. Knowing that I was no normal Londoni person who they could take bribes from, they were reluctant to directly ask me for a bribe to file any of my legitimate cases, so instead they used 'hired

hands'. These are so-called 'dalals' or agents that the police use to collect bribes or to act as middlemen. In my case the police intended to use their famous 'Siddek mamu' (the nickname for their agent), and even to this day he acts as their hired hands in those local police stations around Sylhet.

Although I had the privilege of being able to access higher authorities to take matters forward – as I had the status of being British, the means, and the determination required – the poor in Bangladesh can only gain access to senior police officers' time by hiring or paying these 'dalals', or as I call them, 'vultures'.

Most of the police in Bangladesh – especially in the rural areas – seem to only do their duties for the rich and powerful, as the 'taka notes' or the 'salami' (greeting and gifts) are bigger, and to the politicians, promotional prospects for doing dirty work are more valuable. However, even with corruption, Bangladesh still has some excellent senior police officers who are absolutely honest and sincere in their jobs, sometimes taking extreme risks and working without basic police resources.

I have managed to weigh up the two categories and have found that the corrupt police officers are corrupt to the max, while the best police officers – though only very few – really are the 'best'. They work long, sometimes dangerous, hours during the day and night, and they face discrimination from corrupt colleagues, but they still take pride in their jobs and pride in protecting their people – and all for a basic salary of no more than 11,000 taka (around £100) a month. According to a police officer in Bangladesh, bribery only exists because certain people created that system.

With regards to my situation, I was now a woman on a mission to win – against the world of men and their barbaric cultural practices. If I was going to die, then I would die like a warrior woman, taking some of these men with me. I certainly wasn't going to run back to England; after all, I was innocent of all charges and the land and assets were rightfully mine. If someone wanted my assets they could ask for them, and I wouldn't hesitate to hand them over, but I was determined

not be intimidated or forced to give up what was rightfully mine by a bunch of bullies. I would rather die than give in to criminals.

As a result of not being able to pursue the criminal way of defeating me, they'd even held a press conference in an attempt to drive me out of Bangladesh. The press conference labelled me as a 'gangster', slandering me with my past by bringing up issues I highlighted earlier when I turned into the 'Bad Girl'. This information was, of course, provided by my ex-husband and his hired associates. The situation had become a media story, which everyone seemed to be enjoying. I suppose this was the first time anyone had seen a woman of courageous means, as they quickly labelled me 'the rough girl'.

At the time I didn't really care about what people said about me – I was half crazy anyway.

I can remember how the village men and women used to crowd around just to see the 'gangster rough girl' when I visited the police station, which I had to do many, many times in order to deal with my issues and attend the call of the village elders, the so-called 'punchat bisaris'. When a village man reaches a certain age, he wears a clean mosque hat and a clean Punjabi (a long shirt worn in Muslim countries), and polishes himself with mustard oil so that he glows in the sun. If he also puts on cheap-smelling 'attar' perfume, and can prove that he has a certain level of financial stability or authority, then he earns himself the status of a village judge or 'Bisari'. Most of them, however, are just uneducated, primitive old men who discuss the 'taka notes' or future votes for elections. Usually there is a chairman, a vice chairman, and then the 'members'. Unfortunately I didn't have the privilege of hiring these old men, as the party I was fighting against were settled in that village and therefore had more authority over hiring these corrupt 'Bisaris', getting them to talk in their favour.

I was treated as an outsider, but I was aided by a good investigating officer, who – as a result of his previous service in that particular police station – managed to find some reputable

businessmen and men of authority in the area to speak on my behalf, convincing them that I was being faced with unnecessary harassment by the police and these villagers, whereas I should be supported by the people of Bangladesh for the good work I was doing in their country.

In his words I was a 'diamond' or a gold mine, and he believed I should be encouraged to stay so that I could continue doing my good deeds, bringing in investments and international trade, and helping Bangladeshi people seek a better life in the UK as a result of my licensed immigration work – rather than being harassed.

While I faced these problems – including my life being in danger while I was fighting these disputes against me – I had no support from my husband or his family, otherwise I wouldn't have been harassed as much. The village men would have been divided if my husband and my husband's family had helped me. As a woman, my honesty and basic rights didn't matter; it's a man's word that is valued. A woman has no right to speak up for her rights, so when a man says she's in the wrong, she's in the wrong. That's the attitude of these men out there.

Even when I was in danger – going up against 200 men, as I mentioned earlier – my husband, his mother, and his brother just watched from near their house, doing nothing whatsoever to help. They said they didn't want to be seen to be supporting me and my dispute, as it might get them into trouble with their father in the UK, even though their father had abandoned them long ago.

My husband and his brother helped me to cross the muddy ditch so I could run towards my son, who seemed to be in trouble with the 'village dogs', but as I was running I looked back to see that both of them had run back to near their house and were just standing there with their mother, watching. I stopped in amazement. How could a husband lure his wife into going and fighting with village men on her own?! I was the wife in that family and my husband was meant to be my protector. There was no other way to explain this other than to

say I was shocked, with tears of sadness running down my face.

As a result my crazy mind started working overtime, seeing them for what they really were, so I started to reject my husband's demands to give his family money. In response he decided to come back to the UK to work for his family, excluding me and my children. He also demanded that his mother stay with me in my own family house in order to watch over us. I agreed to this until, due to her frustration at not being able to roam around like she did in the village, she took my daughter to the rooftop – despite the fact that I'd specifically ordered everyone not to take my daughters there because it wasn't safe – and nearly killed her.

I was working in my downstairs office at the time, but due to a strange sense of danger I had – or mother's instinct, whatever you want to call it – I went to the top floor room and asked my babysitter where my eldest daughter was. She told me she was with her grandmother visiting the next-door neighbour. I reminded them not to go up to the rooftop, and my sister-in-law said she'd reminded my mother-in-law about it earlier.

I went back to work, but for some reason I just couldn't focus – by now the overwhelming feeling of danger was extremely intense. So, I went back to my top floor room and asked my son who'd just woken up from his nap if he could find them for me.

To my shock and horror, I heard my son swearing and shouting from the rooftop, so I ran up there and found my son holding my daughter – who was only four years old at the time. When I asked what had happened he said that my daughter had climbed to the edge of the roof and was looking down, while her grandmother just watched her, as though she was waiting for her to fall from the two-storey building rooftop.

I didn't say anything as I was just so thankful to Allah that my daughter was safe, but that didn't stop my son swearing at my mother-in-law. I allowed my son that privilege at least; the evil woman deserved the swearing. An image of myself pushing my mother-in-law off the edge of the roof had flashed

through my mind, but I stopped myself; I didn't want to end up in a Bangladeshi prison, leaving my young children behind. Even so, it was a fantastic thought for me. Instead, I called my mother-in-law's brother to come and take her back to the village, but not before my crazy side came out. I thought there was something seriously wrong with me, being so calm about the situation, but when I tried to complain to her brother and older son, who also came to see what had happened, they brushed me off with a grin as though what was happening to me was a joke. So, I lost it. And I mean, really lost it. I can't even describe it, but my crazy side certainly came out that day.

People tried to calm me down, but trying to calm me down at that time was like ***baptising a cat.*** Of course, when my mother-in-law finally went back she gave a different story to her son, my husband.

My husband's family's needs weren't being met as I refused to support them financially, and by now they were growing more and more desperate as they weren't getting the money I'd been giving them for the past few years. As a result, they all formed a group – together with my ex-husband – to conspire against me, going to the extreme of hiring village 'dogs' to have me killed.

My husband phoned me from the UK and demanded that I go to his village to see his mother, who he claimed was ill. This demand came on the same day I was advised by my legal team to avoid the village, due to the fact that my opponents were getting desperate – as they were losing their judicial battles in court against me – and because they were likely to take any measures to hurt me.

. I told my husband that the other party were losing all the cases against me and were even likely to be arrested and jailed, and that I wasn't supposed to go to the village at this point in time. Again, he wouldn't listen to any 'excuses' and demanded that I visit his mum with my daughters, as his mother was asking to see them. He also said that nothing would happen to me as I was "the wife of the top gangster in the village" and that his 'brother' would make sure no one even said anything to me.

So, I went to see his mother and found out that she wasn't, in fact, ill at all. Then, as I was leaving the village to go back to my house in the city, the other party with the ongoing conflict set fire to their own property and started to shout, "Help, help, they set fire to our house!" Little did I know that this was a trap, as before they'd set fire to their house, they'd barricaded my vehicle in with another vehicle, making it difficult for me to leave the area. Fortunately, my driver and my cousin Dipu managed to push the blocking autorickshaw out of the way just as six men came out to set fire to my vehicle. It was by the grace of almighty Allah that we were able to quickly drive off, unharmed.

The country lane we had to drive down was very narrow and dangerous and we nearly fell into a deep ditch. It was then that I received a phone call telling me another group of men were waiting for us at the end of the village road. There were only two narrow lanes available to us and now we were trapped, as we had no idea on which of the two roads the men were waiting to attack us.

In desperation I called my friend, the original IO (investigating officer), who told me off as he'd warned me against going to the village for my own safety, and was particularly angry that I'd taken my children with me as well. At the same time he was very worried as a result of his previous service as a police officer, because he knew what the village people were like in that area (Tano Gow, Hussain Pur, Osmani Nagar); they might as well be called primitive animals in that they have no shame, morals, or ethics, and they will certainly do anything to a woman who shows any sign of standing up to them. I was all that, so I was a target without a doubt.

The original investigating officer advised me not to go any further but to stay in the open road or the village lane while he phoned the police himself. However, much to my surprise – and equally, his – we learnt that our opponents had already called the police, and that the police crew from Osmani Nagar Thana (second officer in charge) were also on their way. The allegation was that we'd set fire to our opponents' – or enemies' – house.

Wow. A tortoise would have made it faster to a murder scene than the Osmani Nagar police station crew. It really is amazing what a 'pre-arranged' police crew can be made to do in Osmani Nagar, the birthplace of the famous Major Gani Osmani. He must be turning in his grave knowing how the people of his birthplace gang up on women, while he fought to save women from the Pakistan Army in the 1971 War of Independence.

Anyway, my original IO had advised my driver to take the same route our 'beloved' Osman Nagar police crew would take, and not to take the other route where the other hired men were waiting. We were to head straight to the police station; even if I got arrested, it would be a far safer route.

We managed to drive off and were met by the second officer in charge and his crew, who were on their way to find us, but they had to head back to the police station when I threatened them for failing to protect me and my children. With the advice and support of the original IO, I managed to file a complaint regarding this life-threatening incident from primitive village criminals who'd been hired to do the 'dirty work', even trying to kill innocent children for just a few pounds – while the police looked the other way.

This drama continued on to, yet again, the village court – the 'panchat bisaris'. It took months to end, with whole days and nights spent trying to deal with these primitive village politics.

I may remind you that all this drama was unfolding in the presence of my husband's family. His brother and my mother-in-law just watched as me and my children were attacked like thieves by these bloodthirsty village 'dogs'. They didn't come forward or try to help us at all.

The story became clearer later on. Apparently, my current husband and his family – together with my ex-husband – had entered into a contract with these village men to kill me because I wasn't giving my husband's family money anymore. Therefore, I was of no use to them, and by killing me, my husband would be able to remarry and bring his 'Teenage Tart' to the UK. It was obvious that I'd never allow this to happen

under normal circumstances, not to mention the fact that he'd inherit all of my assets should I die. If I had died this way, no one would have suspected him, as he wasn't even in Bangladesh at the time. So, this was an arranged attempted contract killing.

Informants later advised me that a police officer – who cannot be named for legal reasons – had been given 20,000 (£200) in advance to work with my opponents, while the six men hired to set fire to my vehicle had been given only 500 taka each, with others being given between 200–500 taka each (£1.80 – £2.00 UK sterling).

It's worth mentioning that the 7ft x 200ft boundary wall around my house was destroyed the same night, most probably by these same village thugs. In particular, one senior police officer stood there and watched as about 200 to 300 of these village men destroyed the boundary wall of my villa, breaking it into pieces. Come the morning there was nothing left standing – just an empty space as if the wall had never even existed. This was a concrete wall that had been built on my own legally owned plot of land, with all the paperwork in place and the taxes paid to the Bangladesh government. Yet it was destroyed with the blessings of the police.

The scheme to eliminate me was hatched before I'd even left the UK, as my absence gave them an opportunity to pursue their ambition of regaining control of my assets. They must have been disappointed when I returned to the United Kingdom in one piece.

My rice fields were also burnt in the middle of the night by the same petty criminals, and yet again the police did nothing and made no arrests. They knew who the perpetrators were, yet justice had to be bought and I was simply not in the mood. In the absence of security I decided to take the matter into my own hands, since in a place like this a woman has no rights. So, I literally chased the man who was behind the arson with a machete. In my experience, in these types of places only violence solves violence.

The 'Squatter's wife' was claiming that my land belonged to her and that I had fraudulently taken it at the time of my

marriage to her brother back in 1989. She and her family had filed a court case making these allegations against me and my father, but they lost the case after a bitter legal tussle. At one point the judge had called their mother – the claimant in the case – a 'shrewd woman' for bringing the action 14 years after the alleged event. However, these people underestimated me. They never imagined that a Londoni woman would go to the trouble of claiming assets in her ex-husband's village after all these years, but I proved them wrong, showing them I was no ordinary Londoni woman. I have every right to my own property in my own country and I wasn't going to let anyone drive me away. Of course, if they'd asked me nicely to give it to them, I would have only been too happy to let them have the assets.

In the end, their desperate plan was to 'defeat lady Aklima', funded by my ex-husband and aided by my present husband. Fortunately, their evil plan was a total failure. Even after all this, nothing could shake Aklima, and while she survived this battle, the war still continues in other ways. For now, I am Aklima Bibi, and 'The Lady Still Stands'.

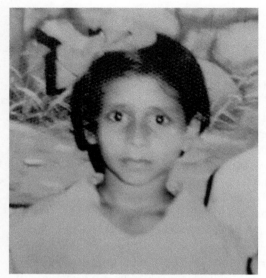

*Aklima in Bangladesh (about 6 years old)*

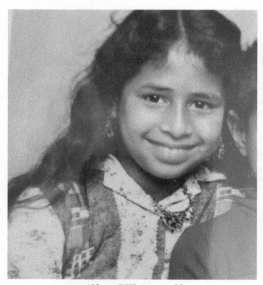

*Aklima (UK) 9 years old*

*Aklima (totally covered bride in the middle)*

*Bride - Aklima Bibi*

*Bridal boat*

*People watching bride (Aklima) being taken away, hearing screams inside the boat*

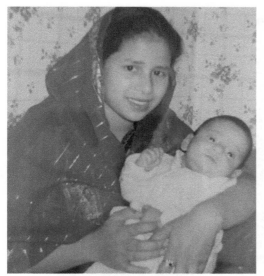

*Aklima with first child*

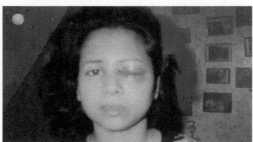

*Aklima, (beaten up after being caught revising for an exam)*

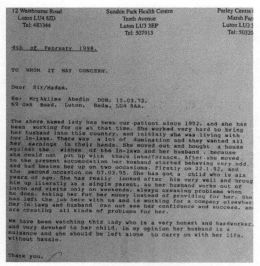

12 Westbourne Road

*GP letter of the abuse*

*Court verdict from the Family Court in Bangladesh, against 2nd husband.*

*Osmaninogor Thana, Sylhet (police station)*

*Aklima (over looking the Himalayas, with a sense of victory, after winning all the court cases in Bangladesh)*

*Campaigning for girls education in Bangladesh*

*Father & daughter promoting girls education
in Bangladesh*

**Juliet Prince**
@JulietPjuliet39

Powerful Aklima Bibi telling professionals need to tackle forced marriage #staffsPDD2017 @StaffsFACS_Dept students

*Father & daughter together in Bangladesh "In the end I was my father's pride & joy"*
*Father - Sawab Ali (1942 - 2017)*

# CHAPTER 12

# End of the 'Living Hell' with my Second Husband, the Present

In regards to my second husband, I've already mentioned that he was having an affair with a 14-year-old girl – the daughter of his mother's cousin – in the village of Korshona, Lala Bazar, Sylhet, and he arranged to bring her to the UK as a family visitor without my knowledge. It later came to light that this was an open affair that had been arranged by the girl's family – mainly her mother – despite the fact that she was a minor. My second husband was also sponsoring this girl and her brother to come to the UK. So, this 14-year-old girl was being lured into having an affair with an adult 20 years her senior so that her brother would benefit from that relationship. It is absolutely shameful how some parents can arrange such an illicit affair for an underage daughter in the name of getting a visa to the UK.

Was I supposed to be shocked or upset? Well, I actually thanked this poor little 'Teenage Tart' because, without her, this brutal monster – my second husband – would still be terrorising me. Instead, he's now busy dreaming of his 'Teenage Tart', and I bet he'll soon be abusing her as she obviously has no other option in life but to obey him.

My marriage to this pauper was my greatest nightmare, but in some ways it was also my greatest gift; because of it, I became stronger and tougher. It's his loss and my gain, and he will pay for his terrible deeds. In other words, paupers can't cope with the good life when it comes to them. In their eyes they become

gods, and they don't see others – especially women – as human beings. That is exactly how this man and his family saw me. As I'd been married once before, he'd constantly say to me, "You should count your lucky stars that I married you; no one else will even look at you. The only men who might come for you are 'tracks'," – which meant no hair (bald and ugly men).

He even beat me up because my parents gave me a sari as an Eid present. I said I'd return it to them, but that wasn't good enough for him – instead, I was to throw the sari in their faces and insult them. Because I didn't do this, he pulled my hair and threw my sari in the bin. From then on, I was ordered not to see my parents on Eid days. I was also beaten up (kicked from one end of the room to the other) in front of not only my own children but my brother and his children too, simply because I wouldn't dismiss an employee he didn't approve of.

His sister, 'Zinuk Mala', was married to my younger brother, and had therefore gained a visa as a spouse. As a result she was making my brother's life a living hell, demanding money all the time to buy expensive saris, and if my brother declined I'd be beaten up by her brother.

Their main intention was to separate my brother from my parents, which would enable them to extort even more money from him to give to their family. I was eventually ordered to tell my brother to leave my parents and to come and live with me, as I was in Bangladesh, and to pay my mortgage – whereas he was living rent-free in my parents' house with ample room for all of them.

When I refused to ask my brother to do this I was kicked, punched, and then threatened with death. My husband told me, "I will cut you into pieces and put you in a sack, if you do not bring your brother to live here and pay the mortgage."

I was to leave the next day for Bangladesh to resume work, which my husband didn't like. He refused to let me go, and I had to call the police, who assisted me in leaving the United Kingdom.

The physical abuse and mental abuse had been so intense that I eventually thought there was no way out. I accepted

this as simply being a way of life. I thought I was one of the cursed humans God had created, and that even God himself was having a laugh – but what had I done so wrong to deserve a punishment so severe?

My husband made sure I clearly understood that if I was ever to leave him, it would be in a body bag. This man didn't even care that his own children were frightened of him, and I knew he could easily kill any of them as he used weapons such as a knife, settee handles, baby walkers, or the Bengali 'da' (a curved butcher's knife) – not to mention how he'd kick me even when I was holding the babies. The number of earrings I lost from the slaps were countless, but I collected the mismatched jewellery so that it could be melted down and remade, assisting my poor relatives during their wedding in Bangladesh.

My son took the most assaults from my husband as he used to try to protect me, and also because he used to answer him back. For example, there was an occasion when my son – who was about 12 years old at the time – came back late from school, though no more than five or ten minutes past the usual time. As soon as he walked through the door my husband threw him on the floor, punched him, kicked him, and then stamped on him while wearing very strong Caterpillar boots – which he'd bought with my money. This was done in front of his own sister, my sister-in-law. When I intervened, asking, "Don't you think that's enough?" he quickly turned on me, swore at me, and ran into the kitchen to get a knife. He accused me of ganging up on him with my son, so in fear and desperation I ran, pushing my son in front of me to keep him away from my husband's reach while desperately holding onto my two daughters. We made it into the front room and I locked the door behind us. My daughters were no more than toddlers at the time, and they were still clinging onto me and screaming.

My cruel, barbaric husband managed to kick the door open, grab me by the hair, and pull it back so that my neck was stretched. He was about to slash my throat when his sister grabbed his arm and took the knife away from him. I still

received the usual share of kicks and punches – which my body now seemed so used to – and even to this day, I've kept the broken-down door frame as a souvenir of my 'living hell' and a memory of my 'cursed life'.

I was also badly assaulted when I was eight months pregnant with my eldest daughter. He kicked me down the stairs, but luckily I rolled down them rather than falling down from the top, so even though I was in pain I was still moving. He ran down to me, and although I thought he might help me, instead he grabbed my hair from the back and punched me on the head and the back, before dragging me across the living room like a lifeless animal and throwing me against the wall. I suppose I was lucky on that occasion as he could have kicked me in the stomach and I could have lost my baby. I don't remember the reason he attacked me that day… he didn't need a reason.

Another time, he made a religious offering to the local mosque of £500, demanding the money off me. I explained that I had to pay the mortgage but I was accused of being disobedient, and as a result he kicked me in front of his own mother while I was feeding my toddlers, then he picked up the baby walker and hit me across my back and the back of my head. While his mother moved my screaming toddlers out of the way I hid under the kitchen table, but he managed to grab me by my hair and pull me out of there. My uncle (who was staying with us, as I mentioned earlier) finally came and stopped it.

These are only a few of the countless times he abused me, but I'm still alive, and what hasn't killed me has only made me stronger.

The most shocking thing was that a number of these assaults took place in front of my husband's own mother and sisters, who did nothing to stop him; they just kept quiet in their room. These assaults happened for no apparent reason, for things such as the babies crying or because he was angry with someone. Mostly, however, it was over money. He would even get angry if I bought clothes for the children instead of for

him. He had expensive taste for a pauper who was begging for food, who stole cows and chickens from the villagers to sell in Bangladesh, and who was no more than a petty thief.

It was the same with his sister, who was married to my brother – she wouldn't visit her other sisters in London without wearing a sari that cost at least £300. She said her older sister would tell her off if she wore anything cheap, meaning anything less than £250–£300, even though she lived in a council house in East London and was constantly defrauding the benefit system – as well as stealing from her husband to send money back to her family. Her husband even tapped the home phone due to her constant interference with other family members.

Many things I did made my husband angry, such as: Why did I listen to classic Bengali music? Why did I watch classic love story movies such as *Wuthering Heights* and *Casablanca*? Why did I take his tabeez (talisman) off that he got his brother to send from Bangladesh, which they took so much effort to secure in silver tubes so that it didn't come off my neck? I was constantly made to wear these until, after a while, they got replaced. As I've mentioned, he wouldn't even allow me to lock the toilet door if I was in there, and most of the time he'd accompany me inside and just stand there while I got on with my business. That's how insecure this man was!

He would watch me every second of the day. He even used to go to work with me and just sit there, waiting for me to finish – and if I was late even by just a few minutes it would turn into an argument and assault. He couldn't even manage to pay a cheque in at the bank by himself; if I asked him to drop the cheques into the bank, he'd make the excuse that he didn't speak English and that the bank clerk might ask him something, which wasn't likely as I'd already written everything down for him, so all he needed to do was queue up and deposit the cheques. If I asked him to man the office while I went to the bank to put the cheques in myself, he'd accuse me of going on my own so I could try to get a boyfriend. So, I would have to close the office during office hours and go to the bank – with

my husband following me, of course. As well as running two businesses and bringing up three children, I still had housework to do – all the washing, cleaning, and ironing –not to mention the cooking. My husband wouldn't have anything less than five or six different dishes of Bangladeshi food.

Also, when he used to work in restaurants he would come home from work to check up on me; when he was supposed to be working in the evening, he would suddenly come in and run upstairs, searching every bedroom as though he was looking for someone. Whenever I asked what he was looking for, he'd say "nothing" and would pretend that the restaurant was delivering in the area – but then he'd say he'd had a tip-off that I'd let an unknown man into the house. This was an almost everyday occurrence, which happened during his employment with an Indian restaurant in Luton, which was about ten minutes' drive from the house. His mother, sister, the children, and I would be downstairs when he ran upstairs, trying to find someone – only God knows who.

This stopped for a few days, but later it turned into, "So who came into the house while I was at work?" This would always come completely out of the blue, as no one ever came by. If I told him this, however, he'd say I was lying and he'd abuse me, swearing at me and slapping me and telling me he had spies who informed him of any men that came into the house. He said that even if my brothers, their wives, or my father came, I was not to open the door to them.

His first job was at a restaurant in Tring, Buckinghamshire. I used to collect him at midnight or later every day, so that he wouldn't accuse me of sleeping with another man while he was at work – which he did anyway if I showed even the slightest sign of tiredness when collecting him. As my son was nine years old at the time, I didn't want to leave him in the house on his own, so I had to take him with me.

This happened every day for about 12 months or so, even though I had work and my son had school in the morning. I even had to do it in the winter months when the roads were

slippery, dark, and dangerous, as most of them were small, winding, hilly country lanes. That was the longest my husband ever stayed in a job.

The picture fits perfectly: even on our wedding day (March 11th, 2000) my second husband was rude and abusive, for absolutely no reason. He even poked the end of the knife towards me when we were about to cut the cake, thinking it was funny. Even as we were travelling from the wedding centre, he was shouting at me and insulting me for leaving my suitcase in my father's village, even though he had nowhere to take me as a new bride other than his grandmother's run-down house in another village.

I knew then that this wasn't a good situation, but I was also thinking of his poor family – his destitute mother and young sisters. They had the hope of a better life now, after what their father had done to them, and I thought that if I abandoned them as well, I'd be cursed. Worst of all, what would people say about me, about the shame and the so-called family honour/'izzat'? But, of course, in the end all these nice thoughts of helping other people cost me my life. Yes, I am alive, but I am certainly not normal. I will never have a decent relationship or learn to trust anyone. I live a life of antidepressants and sleeping pills.

His family certainly didn't think about me when I was abused mentally, physically, and sexually by their brutal abuser. Every time I was physically abused he would say he was sorry afterwards, and if I didn't accept his apology, he'd beat me up again. Therefore, I needed to accept his apology and his promise that this would never happen again. But, if I did accept his apology, I'd have to have sex with him, and if I didn't have sex with him after being abused then I'd be called a whore, and he'd say I was having sex with someone else – in his mind, the only reason why I wouldn't want to have sex with him. He completely ignored the fact that I'd still be hurting from the physical abuse that had occurred earlier.

By the grace of almighty Allah, eventually my husband decided to leave the matrimonial home along with his sister

(who had left my brother and was also living in my house), and I was ready to make sure he never came back. So, I made my own provisions to seek legal help and to start the process of removing him from my life – **for good.** This process of removing him for good had not been easy as I had to file this in a Bangladeshi court. First, I had to file my petition at the Bangladesh High Commission in London, who then referred the case to the Foreign Office in Dhaka. After that the Foreign Office instructed local police to investigate the case, it was then once the report was filed in my favour that I could take the matter through the court process in Sylhet. It was a lengthy process and I was worried that I would be dismissed for being a woman. It was then a wonderful friend, a retired Major for the US Marine Corps from Washington, in US decided that he would write to the Bangladesh High Commission directly and he did. As a result, my case was given priority and taken seriously. I had the report in my favour in no time and I took the liberty of travelling back to Bangladesh to file my case in Sylhet courts and won! I managed to get rid of this  'bazari gunda' second husband for good.

Even to this day, however, I am still getting threats of blackmail and other sources of interference as he still wants me to live with him as the other wife.

I am labelled crazy or mad, but I can't help but ask: what crime did I commit to get stuck in two terrible marriages? Of course, I also ask myself why the hell I didn't leave sooner, and get out of those marriages? All I wanted was a good man, a good husband who loved me for who I am – not 'what' I am.

My whole life – and especially with my second husband – I've felt like a caged bird. I walked, I talked, I laughed, I ate, but I wasn't in control of my own mind. I didn't want to live with him or be in this situation, but it felt as though someone had control of my mind; my heart belonged to myself but my mind was controlled by him. Most weekends I felt suicidal, but strangely, although I wanted to kill myself I didn't actually want to die. I was desperate to hang myself somewhere or fall under

a moving car, but it wasn't what I actually wanted to do. It was as though there were two versions of me, and one person was telling me to kill myself while the other told me the opposite.

I was like a living zombie, and although my family and the outside world saw a lively, attractive, successful, happy-go-lucky woman who was full of life, I had no one I could turn to for help; he made sure I was unable to do so, and he had full control over me.

As I couldn't find anyone to help, I felt as if I were withering away inside, and I just wanted to drop dead. Oh, how desperate I was for someone to hold me tight and comfort me! I just wanted to curl up and hide in someone's arms. There were so many people around but there was no one to help me.

Of course, the assaults I experienced on these days were worse. I was depressed, as the doctors had explained to me, and sometimes I didn't even know what was happening to me. As a result of these depressive feelings I'd be more likely to answer back or be rude to him, meaning the beatings and assaults would be worse.

I had to live with this depression, as the doctors explained to me, and I also had to take many antidepressants such as Diazepam, Seroxat, and a dozen other types of sleeping pills, which never helped at all, even if I took six at a time.

Even to this day, I still suffer from what the doctors call 'psychotic attacks', where I experience all sorts of mental and physical medical problems from sudden fevers, headaches, back pains, and blackouts, to feeling suicidal. My kitchen cupboard is full of medicine that I keep on taking even though there's never any change to any of my symptoms. Over the last year or so I've been to my GP a number of times and have been referred to various specialists and consultants, none of whom can find the exact problem or cure. My mental and physical strength has been completely drained, and I doubt I will ever have a mentally normal life.

Why didn't I leave earlier? Why was I so scared of leaving? It is extremely difficult for someone who hasn't *experienced*

***domestic abuse at the hands of brutal and evil men to understand.*** The fear was just too great. I cannot even begin to explain it; it has to be experienced in order to be understood.

I only leave my petition to Allah for punishment; I believe in 'what goes around comes around'. I thought I'd married a traditional man with whom I could share Islamic culture and tradition, and I'd thought my children would learn these things too, but it simply wasn't the case – with either marriage. Nevertheless, I eventually had the courage to leave them for good… better late than never.

CHAPTER 13

# My Father's Pride and Joy, Third Generation of our Kids & My Final Chapter

## My father's Pride and Joy

I'm glad I didn't have any sisters born to my father, as I wouldn't have been able to bear seeing my sister go through the same things I did in order to better the lives of my father's brothers and nephews. My mother was useless and stupid; if she wasn't, I could have turned to her for comfort when I was a child. Yes, she's there for me now, and she helped me out with my children – and without my parents I wouldn't have been able to carry on with my studies and work to better myself – but she could have been there when I was young. I was constantly arguing with my mother rather than turning to her for help. When she was supposed to be supporting me, she used to join her brother (my father-in-law at the time) when he cried his crocodile tears. I was a lost child in need of emotional support and love, and I couldn't get this from my parents when I needed it the most. The only person who was always there for me was one of my younger brothers; he was always looking out for me and taking me out on trips together with my son. He treated me like a little sister, even though I was older than him. With regards to my mother, I think

that's just what mothers are like in those cultures, and at least she was there for me in her own way. Her father taught her to be a man's slave and she did the same with me. Only, I had a brain of my own to question these teachings and I disagreed. I am never going to be a 'man's bitch' and neither are my own daughters. I will be my own BITCH (Babe In Total Control of Herself).

As for my father's extended family, his pride and joy who scrounged from us while we suffered here in the UK… well, they turned out to be a bunch of morons with no education, no intelligence, and now no hope, as they never utilised the money they received from my father over the course of many years.

Now that we're all grown up and independent, he isn't giving anymore – which means no benefit money for the fucking useless bastards back in the old country. They had all our money while we suffered, but now the tables have turned – us siblings took the opportunity to educate ourselves and get good jobs. And we did it all by ourselves!

## 'The Lost Cause': The Third Generation of Our Kids.

We have lost many of the third generation of our children, the children of no hope that came out of those hundreds of forced marriages of the second generation. The ones who fell into crime, drink, drugs, guns, violence… the nice, polite young Bangla boys 'fwain' who became the trainee 'Zamaykan khobiss bastors' as they're being called – the 'freshies' from the old country, according to the newcomers… the ones who think we're too modern, yet they want to marry us or use our children to gain visas… the ones who think they're so perfect while degrading us mothers and our kids. Yes, you can say 'the broken home kids', as I've heard them called. "What do you expect from your son? He comes from a broken home!"

However, these children are a 'lost cause' who lost their paths because of the first and second generation of men and their

behaviour towards us. The misogynistic cultural behaviour and the British government are too blind to notice.

Yes, they are the baseball-capped chavs who address you as 'Bruv' or 'Boss' whilst out walking their Alsatians and Rottweilers, but they're far better than a lot of the hypocrites I see in society. At least they have far more morals than the older generation, who are the main cause of their distractions. They caused these kids to become the 'lost cause' of modern society. I hope for the best for these kids; I hope they find their peace. As for me...

## My Final Chapter

### *I Salute my Struggles of the Past as they Present My Better Future*

My life starts with a big smile every morning for I have achieved great things from my great struggles. Best of all is that I have completed my education! I hold an advanced law degree - LLM (Human Rights Law) from the University of London, I am a lawyer for a reputable law firm, and my story was told in a BBC documentary that was aired in January 2015. My son is now a construction engineer for the local government and is doing extremely well; he has a beautiful young lady by his side as his wife. My daughters are bilingual. With English as their first language, they can also speak, read, and write fluent Bangla, as well as learning Arabic. They are also only three grades away from their karate black belts.

Great things can be achieved through education, no matter where you're from. Men tried very hard to stop me from completing my education and turn me into their slaves. They succeeded for a while, but I was determined to prove myself and I did in the end. Not only did I complete my education, but I am independent and successful.

*"Education gave me knowledge, knowledge gave me power – power to be my own Free Queen."*

Furthermore, I have been successful in obtaining a divorce in the civil court in the UK as well as successfully prosecuting my second husband for bigamy and abuse in a Bangladeshi court with the help of my friend – Retired Major from Washington. My second husband now has a warrant for his arrest in Bangladesh for his part as an abuser and a bigamist.

For now I will take life as it comes as best I can, though I don't think I will ever fully recover – I guess I will always be the crazy woman that no man will ever be able to cope with, but in my opinion *I am the reflection of the men from my past. They brought out the worst in me, they provoked me until my ugly side came out, and now they play the victim.*

They tried to throw me into the storm but, instead, I became that storm that they themselves threw themselves into. I am not crazy, I am just a badass warrior woman, and behind this badass warrior woman are the men and the society who made me this way. And for that I say THANK YOU!

## My Father's Immigration to the UK & His Real Pride and Joy

Despite my struggles in life – and what my father did or did not do for me – I see my father's *immigration to Britain as the greatest gift he could ever have given me*. Without his immigration to the UK, I would not be who I am today; strong, independent and successful.

In the end my father had provided vital support for me in many ways, before he passed away in 2017. I never heard him say it but many people in the community both in the UK and in Bangladesh said that he was proud of me. He said to people "my one daughter is far better than all the sons and nephews put together." *In the end I was his Real PRIDE AND JOY.*

CHAPTER 14

# 'Honour and Izzat' of Women and Marriage in Islam

Islam gives greater powers and privileges to women than men – it accorded women rights over 1400 years ago, which we now take for granted. Islam offers women dignity, justice, and protection.

*"And of His signs is that He created for you from yourselves mates that you may find tranquillity in them; and He placed between you affection and mercy. Indeed in that are signs for people who give thought."*
*(Quran, the Romans 30:21).*
<div align="right">ALAM (2007) THE ISLAM GUIDE P. 289.</div>

*"O you who believe! You are forbidden to inherit women against their will. Nor should you treat them with Harshness..."*
*(Quran, Women 4:19)*
<div align="right">ALAM (2007), THE ISLAM GUIDE P. 282.</div>

*Allah especially orders the kind and just treatment of daughters.*
<div align="right">ALAM (2007) THE ISLAM GUIDE P. 280.</div>

As Prophet Muhammad (PBUH) said:
*"Whoever has a daughter and does not bury her alive, insult her and does not favour his son over her, Allah will enter him into paradise."*
<div align="right">ALAM (2007) THE ISLAM GUIDE P. 282.</div>

If we look at other civilisations in history we will not find women playing a major role in its establishment. Islam, on the other hand, has acknowledged women's efforts in its establishment. While other civilisations have struggled hard with aggressive campaigns for women's existence, the women in Islam have effortlessly been awarded liberties and privileges from their Lord. The carpet of ease and dignity as a daughter, as a sister, as a wife, and as a mother is rolled out under the woman's feet in Islam, and she is entrusted with important tasks that beautifully adorn her nature.

According to *The Islam Guide* (Alam, 2007), there is absolutely no difference between man and woman as far as their relationship with Allah is concerned; both are promised the same reward for good conduct and the same punishment for evil conduct.

The Quran says: '*... And they (women) have rights similar to those (of men) over them in kindness...' (Quran, the Heifer 2:228)* Alam (2007) The Islam Guide p. 282.

In terms of marriage, the Islamic teachings – the teachings of the Prophet Mohammad (PBUH) – always encouraged harmony between the spouses. The idea of 'forced marriage' is completely forbidden, alien, and hostile to the teachings of the Prophet Mohammad (PBUH). Women have the right to choose their partners for their lifelong commitment, and the woman must give her free consent for the marriage to go ahead. Alam (2007) The Islam Guide p. 288.

Once entered into marriage, women retain their maiden name, *and their unique identity*, unlike other religions where a woman is expected to take her husband's name. As well as all the required provisions for her welfare that the husband is obliged to provide, women also have the right to a dowry (mahr). Furthermore, a woman's wealth and her earnings are her own, to do with as she wishes.

The Quran also describes the relationship between husband and wife graphically: "*They are a garment to you and you are a garment to them" (2:187),* and in another verse (7:26): "*The*

*best garment is the garment of God-consciousness."* Women and Shariah (Islamic Law) 1996, p. 41.

As Rahman further states, "The importance of this smile can be realized. It requires that a husband and wife should be as garments for each other. Just as garments are for protection, comfort, show and concealment of human beings, so *Allah expects husband and wife to be for one and another."*

Prophet Muhmmad (PBUH) preaches of kindness towards women, including: *"The best of you are those who behave best to their wife."* (Mishkat al-Masabih, transmitted by Tirmidhi). Alam (2007) The Islam Guide p. 284.

Not only does a woman have the right to decide her marriage, but she also has the right to terminate an unsuccessful marriage. When divorce is unavoidable, it is stated that teachings of Islam instruct the *husband to depart from his wife peacefully with no malice.* Alam (2007) The Islam Guide p.288.

Furthermore, when a woman becomes a mother in Islam, her seat of honour and dignity becomes extra special, as Prophet Muhammad (PBUH) says: *"Paradise lies at the feet of your mothers"* (saying of the Prophet Muhammad (PBUH), recorded in ibn Majah and Ahmad). Alam (2007) The Islam Guide p. 291.

# CHAPTER 15

# Political Involvement of Women in Islam

Islam has always allowed women the right to participate in public affairs. Islamic history reveals a number of high-profile women in society who played important political roles. For example, during the Caliphate of Umar ibn Khattab, a woman publicly debated with him and was proved to be correct in an argument to which the leader, with humility, declared before an audience: *"The woman is right, the Umar is wrong."* Alam (2007) The Islam Guide p. 286.

Other famous political figures include Lady Aisha, one of Prophet Muhammad's wives, who is regarded as one of the greatest scholars of Islam. She has narrated numerous Prophetic statements and is amongst the few who have given many religious pronouncements and verdicts, as well as explaining many verses of the Quran.

Lady Hafsah is another influential woman in Islamic history. She was an intellectual who collected copies of the Quran as it was dictated by Prophet Muhammad (PBUH) and written down by his scribes. This was the text that was handed down to Caliph Uthman ibn Affan and established as the standard text that was circulated throughout the Islamic world.

Protecting women's rights is an important theme in the Quran, and it admonishes those men who oppress or ill-treat women. As already stated, Islam gives women divine rights – especially to wives – but as wives we have important roles to

establish peace and harmony, as Islam teaches: *"The best women are those who are best to their husbands."* Alam (2007) The Islam Guide p. 286.

Therefore, when it comes to husband and wife, Islamic teachings tell us to love, honour, and respect each other as the Quran states:

*"Indeed, the Muslim men and Muslim women, the believing men and believing women, the obedient men and obedient women, the truthful men and truthful women, the patient men and patient women, the humble men and humble women, the charitable men and charitable women, the fasting men and fasting women, and the men who guard their chastity and the women who do so for them Allah has prepared forgiveness and great reward."* (Quran, The Clans 33:35).

# About the Author and This Book

I, the author, was not a professional writer when I wrote this book. In fact, it was just 'notes' for medical practitioners so that they can make further assessments on my medical conditions, mainly my mental health issues.

These 'notes' were giving me a clear picture of my past and encouraged me to keep on writing until I was inspired to write a whole book. As a result, I found much needed answers or solutions to my problems.

This book is my story, written in my own 'raw' language, true and accurate without any romantic notion added to it. After writing this book, I felt empowered in many ways, in fact, I felt liberated and cured from my so called mental health issues.

# Summary

*"In the hopes of reaching the moon men fail to see the flowers that BLOSSOM at their feet."*

(Albert Schweitzer, *Theologian*).

*"In these circumstances, when you've got a British girl, often you're seen as a commodity."*

*"Because she's got a passport, he can get a visa"*, and work in the UK.

*"We're seeing a generational strategy to emigrate to the UK."* (Alan Morrison, the British Consul in Bangladesh, BBC – *My Forced Unwanted Wedding*, 2011).

My story is no ordinary story; it tells of a whole cycle of violence, from forced marriage to domestic abuse, and police corruption to attempted contract killing.

My sin – being a British Bangladeshi woman! I was used and abused in the name of money, property, and – most importantly – a UK visa, a British passport. I was a modern-day slave in Britain in the name of honour and izzat, an item who was traded for my extended family's better life and then used as a commodity for my husband's entire family to live off.

I was an educated, intelligent British woman, an international businesswoman, an inspector, an auditor, and a lawyer, but I was still a caged bird, a zombie, a robot doing what I was told to do. But why?

# Bibliography

Alam, R.B. (2007). The Islam Guide (An insight into the faith, history and civilization). Exhibition Islam Publishers

Doi, A.R.I. (1996). Woman In Shariah (Islamic Law). London: Ta Ha Publishers.

http://www.hiddenhurt.co.uk/personal/stories.htm cited August 10 2020.

Believe and Achieve, a collection of inspirational thoughts and images (2010): Parragon Books.

http://www.brainyquote.com/quotes/quotes/d/davidhackw233205.html#UfQJ2E0TsWOxsHoc.99 cited 23 April 2014

http://www.brainyquote.com/quotes/quotes/r/ralphwaldo122579.html#XeMpTbbZaCllsPKb.99 23 April 2014

https://www.goodreads.com/quotes/tag/women?page=2 cited 20 May 2014

# Extracts of My Life

## 1. "British Bandit Queen" fought off mob of village tribal men and survived honour killing attempt.

I am Aklima Bibi, a British woman who was forced to fight off a death mob of village tribal men in Bangladesh to keep my honour as a woman. I feel compelled to write this story because this sort of violence against women in Bangladesh is so common. Women are not even regarded as second-class citizens. Nothing changes and will not change until someone speaks up. I am the first woman to do so. I want my story to inspire other women.

### Travelling to Bangladesh
I was posted to Bangladesh as Operations Director for a European multinational in March 2007. Despite having been taken to Bangladesh and forced into marriage when I was only a teenager, there has always been a part of me that seeks to return to my birth country.

I had emigrated to the UK in 1981 when I was just eight years old, with my mother and siblings, to join my father who had lived there since the 1960s (from the age of 19).

But as soon as I had obtained a visa to enter the UK, within a year – when I was nine – I was engaged to my first cousin. I was taken to Bangladesh as soon as I left school and forced to marry him. There, engagement is a promise made by parents, sometimes at birth, for marriage at a later date.

I endured ongoing violence beyond belief at the hands of my in-laws and my husband, including mental and physical torture. On my wedding night, I was drugged and raped by my husband. On another occasion I was beaten up so badly that I nearly lost my eye. My crime? I was caught revising for an exam.

Nevertheless, after many years of violence, I did manage to obtain a divorce. But as a divorcee I was stigmatised and shunned by my community in the UK and in Bangladesh, being seen as a worthless woman.

However, I was eventually free and re-enrolled to finish my education. As a result I have been successful in obtaining prominent job roles – rare for Bangladeshi women of my generation.

I proved that I was not worthless. By this time my parents had realised that I was determined to succeed – especially my father, who came up to me and said, "Don't bother with that worthless man, go for what you want". I also found out that he'd apparently held a knife to my now ex-husband's throat soon after, at a busy bus stop, telling him he'd cut his throat if he bothered me again.

However, my ex-husband felt his honour had been violated; as a Muslim man, he believed it was he who could divorce me, not me divorce him. Although he stopped harassing me for a while, he continued to torment me after I'd travelled to Bangladesh for this posting. He made many false accusations, and filed court cases against me by bribing police officers and village tribal men via the panchatt, or village court.

## Mob Attack by Tribal Men

On a dark, gloomy day in Bangladesh's monsoon season, I arranged to travel from my city home to survey land that I owned in the same village as my ex-husband. The village roads were muddy, slippery, and dangerous, infested with snakes, leeches, and mosquitos.

I had to have the survey done in order to defend myself properly against the cases filed against me, so I travelled with my

son about ten miles to the village of Hussain Pur in the Osmani Nagar area of Sylhet, where some of my land was situated.

On entering a small muddy road into the village, I phoned the surveyor. He was scared because he'd been threatened with death if he came to do this survey for me. However, he agreed to come after I guaranteed his safety and offered him higher fees.

The sky was getting darker with every passing minute and we could hear a distant thunderstorm brewing. After travelling for about two miles from the local bazaar along a small, broken, and muddy road, we reached the path that would lead us to the village. I was looking at a 6 ft boundary wall surrounding the house and a firmly locked 7 ft metal gate. Men's voices could be heard. "She is a Westernised woman who has no place in society here!" I heard one cry.

I heard men shouting within the boundary wall and my heart sunk with fear. I ran towards the boundary wall, falling on the slippery, muddy path several times in my frantic attempt to get there as quickly as possible as I feared my teenage son might be under attack.

## Welded gate

My heart was racing and I was breathless as I reached the gate, but it was welded shut. I kept shouting my son's name but I couldn't hear him. As I was hitting the gate with an axe on the welded area, the tropical thunderstorm broke out above me with loud thunder. At the same time, the hinges broke, and with whatever strength I had left I pushed the gate open to be met by many men with spears and curved machetes.

Older men were standing behind them, shouting, "Get her! Don't let her get away!" In the midst of this violence and deafening shouting, I was relieved to see my son running to me, pushing men away as they turned towards me, shouting out, "Finish her off!" A machete flew past me – missing me by an inch or so – then a spear and a big chunk of wood.

My son grabbed one of the men as he came towards me with a machete, punching him in the face and knocking him

to the ground, while I pulled another by his sarong and hair, slamming him against the wall. Then I pushed another to the ground, kicking him in the head before putting the machete to his throat. When 10–11 police officers arrived, they did nothing because I was a woman – they chose only to listen to the village men.

The mob – all men – intended to kill me with their weapons. They had been ordered to have me killed by my ex-husband from the UK. These village men did not even hear my side of the story simply because I was a woman. I had no say and no rights.

I defended myself and my son with courage, fear, and rage. My fear overpowered my sanity and forced me to defend myself by whatever means necessary, even if I had to kill. Despite the violence, I did get my survey done, ready to continue defending myself: I needed to prove that the court cases against me in relation to my land were false.

At the end of all this, one of the elderly men walked past me. He looked back at me as he went, slowly shaking his head as he said to another man, "Britishor ranir dhakaith" – "British Bandit Queen".

## 2. The Legal Slaughter House

*"There is a stubbornness about me that never can bear to be frightened at the will of others. My courage always rises at every attempt to intimidate me"* (Jane Austen, *Pride and Prejudice*).

I set off with my family and, after a long-haul flight, reached my destination: Sylhet, Bangladesh. If heat and exhaustion weren't enough, I had forgotten to get a visa for my youngest daughter, so I had to get one on landing. On top of it all, you would think my present husband being a Bangladeshi would help me with the situation, but no, not him. He just followed me around like a pathetic puppy dog, rather than helping me.

Once I'd finished getting the visa sorted, I then tried to get my goods released from the cargo warehouse. When I got there, the cargo officer seemed to have a different agenda when he saw a woman wanting her goods. Being from a male-dominated country, he thought I was his 'lottery' to earn extra money. He gave me the whole explanation about how he was going to tax me, piece by piece, even though I showed him the taxing notice that I'd got from the airline. This shows which goods are taxable and which are not. He thought that I was an uneducated British woman; his usual 'prey'. So, in frustration, I used my own method of showing him that I was educated enough to confront him on his level and that I was not going to allow him to think any less of me.

The 'bitter bitch' attitude had to be released from my inner self. He was gobsmacked when I answered him back, telling him that he was nothing more than a common thief, trying to 'screw' foreigners, and that I would be back with the military authorities.

"Control your wife!" he said to my husband.

I looked back at them with such a stern 'no nonsense' expression that all they could do was look at me in silence. As I left the office, furious, I was shouting out every Bangla swearword I knew. I suddenly realised that I knew quite a lot!

In 2007, the country of Bangladesh had just come under military rule, so the old bribery system was almost impossible to continue during the new regime. I came back with a major, who, coincidently, had the same name as my ex-husband. Thankfully, the major was very annoyed with the story that I told him about the cargo officer and followed me to the warehouse where my goods were being held. I took him straight to the cargo manager's office. The major took out his wooden stick and banged it forcefully on the cargo manager's desk, which completely startled the cargo manager, who nearly wet his pants! My items came out of the warehouse very quickly after that exchange! I paid 1500 taka, approximately £15, for the tax owed, as opposed to about £5000 that the 'dickhead'

cargo officer wanted as a bribe. I further surprised him when he tried to use the technical terminology relating to international trade, such as LC and TTs, to which I replied, "Why the fuck are you using Letters of Credit (LC) and Telegraphic Transfers (TTs) for domestic cargo?" His eyes grew wide with shock as he realised I was educated enough to understand what he was talking about. He wasn't aware that I was a qualified international trade advisor with many years' experience. I had also just been posted to a new job as operations director for a multinational European firm.

After eventually leaving the airport with all the issues successfully resolved, I then prepared for my attendance at the Sylhet Courthouse. Sylhet, Bangladesh, is a city well known for its bribery and corruption. This is a place where my life's memories have been forever imprinted in my head.

My horror story began when I was a teenager, when I was 'bought' as a commodity, given alcohol, and drugged and raped by my husband when I refused to accept him as my husband. This 'fucking son of a bitch' took my honour and my dignity all in the name of getting a visa to the UK. Until then, my life had been normal, but now I was about to enter the Sylhet court system.

But I am different now; I was not about to be taken advantage of, because I'd learnt a lot since experiencing 'life is not a bed of roses'. In fact, my experience taught me that life is really a 'bitch'. It's about the survival of the fittest, especially when you're about to enter the court system in a country where corruption is regarded as the national sport. The local court system is no less corrupt than that in the main capital city. Any participant in the legal system better have money to feed this corruption; otherwise, your case is never given the proper attention. If you come without funds, they make sure you will 'die a death of a thousand cuts' through the corruption that is embedded in this system. In order to level the playing field, many citizens not only sell their houses, their livestock, and their 'last drop of blood', but many also certainly consider – and

some follow through on – selling their daughters in marriage to gain the financial upper hand in court. Unless they have relatives or family members working for the judiciary, for the law enforcement agencies, or – better still – if a family member is a politician, there is little or no chance of success.

That day, I had several court proceedings against me requiring my presence and, somewhat uncertain as to who and where my accuser might be, I met my lawyers in the hectic number five bar of the Sylhet courthouse. There they were, my lawyers – five of them – huddled together in a big, open-plan court consultation area. There was no privacy; it was open to anyone and everyone. Even the beggars stopped to watch and listen; no doubt they were spying. The courthouse was also named by me as the 'legal slaughter house', for the reasons I've described above. We entered the grounds, and now we were playing their game. I had left the honour of distributing court 'salami' or bribes to my cousin, who accompanied me. He started paying gratuities to the guard on the gates, then the tea boy and the printer's boy, working his way through the entrance on to the messenger, the lawyer's assistant, a court clerk, and the court usher, in order to ensure that we were seated properly – he even bribed the beggars.

Beggars are very clever professionals, who, when compared to the lawyers, are far more worldly when it comes to intelligence. They come in all shapes and sizes. Young, old, handicapped, blind… even those who demand payment by saying, "Give me one pound, lady." They can't read or write, but they sure can act as a human Dictaphone within the court premises – as well as acting as your spies, with guaranteed results. I call them the 'specialists'.

After all that glad-handing I was finally seated, and I looked around the room, thinking of all the people my cousin had just bribed to get me to this seat. I was the only foreign woman there; dressed in jeans, but wearing a scarf and a long shirt. The eyes of the other lawyers, the criminals on trial, and the defendants – all of them men – just stared at me. They had

probably never seen a woman in court without a burka on (a long black gown covering a woman's body from head to toe with just the eyes showing). I wondered what they were thinking. My experience tells me that they are threatened by a woman and therefore prefer to silence her. She is forced to 'shut up' unless she has a father, a brother, or next of kin who is a politician, police officer, judge, etc. Little did they know that I was rich (the Bangladeshi equivalent of rich anyway) with ten brothers in the UK. A 'spicy spitfire' with queen cobra looks. A 'bitch' with an attitude and a British passport, that's me!

I stopped myself from shouting, "Fuck you all! I've had it! I'm not taking any more shit from men who used and abused me!" Instead I held it all inside, pending the outcome of my case.

This crowd of staring men, having no interest in my issues – only in me – were continuing to look my way so obviously and blatantly. If any of them were handsome, I would have been tempted to wink, flick my hair, or even try bouncing my boobs. But, no. They were utterly ugly men with perverted stares. I was ready to spring on them my bitch queen cobra look, which sends out the message: 'hiss!' Fortunately, they got the message and cautiously watched me from a distance.

When the session started, I just sat there. All eyes in the courtroom were on me. It had taken much effort to understand exactly what I was being accused of, but I knew it was something to do with my ex-husband, who I refer to as a 'loser'. He was trying to settle what he would describe as 'old scores', but the loser was using others to do his dirty work in Bangladesh because he didn't have the courage to face me himself. He hadn't even visited Bangladesh since he'd left for the UK after getting his spousal visa approved, on the basis of being married to me. And this is how he paid me back? Bastard!

Last but not least, there were the judges. Even if you are innocent, if you don't pay your dues you are found to be as guilty as hell. In saying this, there are a few good judges. When I say 'few', there are maybe one in a thousand, but there are

some young, exceptionally good judges, especially those young men who are newly graduated as judges and magistrates. I say 'men' because there are literally no women judges in this city as far as I know (at least in 2008 –2009). However, due to the amount of corrupt persons in the system, it will not be long before these good individuals are forced to put their ethics and morals aside and are coerced to join the majority of the corrupt – unless they are people who can endure the pain and suffering or perhaps even lose their jobs for their standards, their ethics, and their morals, like my grandpa did. The choices for these 'few good men' carry great consequences. I do not see how a minority of good individuals can take on the majority of the evil and corrupt system, but I hope for and wish the best to those few trying to survive the system while practising and implementing their ethics and morals. For "Every actual State is corrupt. Good men must not obey laws too well" (Ralph Waldo Emerson). It is very sad that those true values of our forefathers have vanished, being replaced by the modern world of greed.

My lawyers explained the particulars of the petition to me in Bangla as they did not speak English. This petition had been put forward by my ex-husband, who stated that, at the time of our marriage, a day before the wedding both my father and I had forced him to accompany us to a nearby hotel. Once there, we had forced him to sign papers transferring all his assets over in my name as a dowry claim. The particulars of the case further went on to state that my ex-husband was an only son and that his father had ample assets, so therefore he was a bachelor who had no desire to go to the UK and marry a Western 'rough' girl like me. These assets that he spoke of were the assets I'd found out about many years later, which were in my name.

The lawyer further read out, "It says you were a disobedient wife, a Westernised girl, rough and streetwise, who had no regard or shame for your culture or religion."

After this initial entry, and having explained my case, I was told to appear at the hearing at eleven a.m. the next day. "Please

make sure you wear a sari," my lawyer said to me. I looked at him, then looked at my cousin, in the same way I'd looked at the people in court, so tempted to say "arsehole". Instead, however, I gave him a big smile, which was my own way of saying the same thing. I departed, unsatisfied, and reappeared in court the next day as advised. I wore a sari with a normal, very tight blouse; my breasts were very obvious, and my tummy was showing. Modesty, hey? I can get down to their level if they want me to. Thinking back, my jeans and shirt were more modest than a sari, but hey, 'this is a man's world'. A woman in jeans must be regarded as Westernised and therefore superior and intimidating.

After a discussion with my lawyers, they wanted to confirm that I knew enough of the Bangla language to go on the stand, to which I replied in the affirmative. As I entered the sweltering hot courtroom – which was overcrowded and dusty, the ceiling fans hardly working – I was watched by all the men, as well as being sized up by thirteen of my opponents. Some of them I recognised as persons I had given charity to during their time of need, but now it seemed they'd been brought out to provide evidence against me in court – no doubt bribed by my ex-husband. I said hello with bitter disgust but with a big smile on my face to hide my true inner anger. I suppose I was keeping calm, trying to show them that I was in control.

My grandpa and my cousin had accompanied me to the courtroom and my lawyers asked me again if I was sure and confident enough to get up on the stand, especially as I had to give witness in the Bangla language. They were worried I wouldn't be able to speak Bangla properly.

I replied, "Yes, I am, and how many times do I have to repeat it?"

So, the judge called me to the stand and asked me some basic questions to clarify who I was, and then my lawyer said, "I have asked my client to come to the stand and to confirm for the records that she is here, but I do not wish to ask any further questions at the moment, Sir – not until the next hearing, as she has only arrived from the UK recently."

However, the opponent's lawyer objected, saying, "She is on the stand and we have the right to question her, Sir."

My lawyer tried to object but I stopped him, saying that I was willing to answer any questions. The judge was impressed because he'd thought I would be nervous.

"Are you sure?" he asked. The Judge's Bangla dialect was slightly different to the Sylhet dialect, which I could speak fluently.

"Yes, Sir."

So, the opponent's lawyer went on to ask, "Isn't it true that you and your father tricked my client into marrying you?"

"What do you mean?" I asked.

The lawyer continued, "My client is an only son. He did not want to go to the UK but you and your father tricked him into marrying you so that you could have his lands."

I paused and looked around. With the eyes and ears of everyone in the courtroom focusing on me, I said, "Of course. My father could not find a suitable groom for his only daughter with a 'British' passport and six British sons at the time. So I guess he had to kidnap your client in order for your client to marry me, or else I would die? As you can see, am I so ugly that no other man would have married me, not even for England?"

My lawyers burst out laughing – along with all the other people in the courtroom – because they found the question hilarious, especially as the opponent's lawyer had said that his client did not desire to go to the UK and that I had tricked him into marrying me. However, the opponent's lawyer was not impressed, and neither were his other clients, who were standing in the courtroom. He went on to say, "No disrespect to you, young lady, but isn't it true that you'd had a love affair with our client prior to the marriage, since you were a child?"

I replied, "I thought you said that my father and I forced your client to marry me. Are you changing your mind now? If you say I'd had a love affair with your client since I was a child, you have to look at the age gap between us and decide if he had committed an act of child abuse, which is against the law, even in Bangladesh."

I then asked, "What is your next question?" but he did not have any further questions. Instead, he went on to say that the lands and assets were in the control of his clients, and pointed to the caretaker in charge. He stated that he would prove that it was a fraud committed by my family. The hearing was adjourned for a later date.

"You need to show that you have control of your assets," my lawyer said to me after the hearing. Assets? I wasn't interested in the assets so much as I was angry. I was angry that they thought I was a rough, street-cultured woman, who had no shame for religion and culture. That I didn't listen to my husband or my in-laws and that I was uncontrollable, shameful to society, and needed to be put right!

The witness statement from my ex-husband, who was still in the UK, stated that I'd beaten him up and kicked him out of his home; the house he said belonged to him. He even said that I'd chased him down a motorway in the UK and had hijacked him for money. He further went on to say that I wear miniskirts. In actual fact, I had been labelled as anything and everything that would brand me as being an un-Islamic woman in a male-dominated country, and therefore he thought he would win his case against me.

It was very embarrassing but funny at the same time, because I became somewhat of a mini-celebrity in the courthouse as more and more people started gathering at the hearing. Even the media took an interest; all the main newspapers were now coming in for the story. I had to win the case for the sake of my honour; I couldn't lose. It was a case of 'do or die'. My blood boiled with rage.

A dangerous combination of emotions ran through my mind as the lawyers read out the particulars of my case. They also said that I had to regain control of the land; otherwise, I would lose the case. I looked at my lawyers like a woman on a mission and said, "Consider it done." My land is my land. If they want it, they can ask for it and I will give it to them without hesitation, but to label me as the world's worst woman

in a Bangladeshi court in order to defeat me for having left my husband? My lawyers looked at me in silence, amazed that I was actually being serious but equally concerned that I was being too bold (or just brave). One of them said, "Village politics are dangerous. Even the police don't have any control over village politics."

I looked at him and said, "There is a first time for everything. I will get what you want. Just make sure you do your job properly." He said that he would get one of the best land dispute lawyers to take over my case, adding that he'd recently won a very famous case. "He's not cheap, though."

I responded by saying, "Get him on board as quickly as possible then," and left the courthouse with my cousin.

I was walking so fast that people had to move out of my way, almost falling off the path as I came through. I was not doing the usual 'women's walk', which I call the 'bridal walk'. A bridal walk is what is expected of a Bangladeshi woman as a mark of respect to men and society. This is where a woman has to look down and walk behind a man at such a slow pace so as not to look as though she is better than the man – with the added bonus of looking miserable to show that she is fearful of the men around her. I have never managed to do this walk and I was not about to start now. I walk at my normal speed of maybe five miles an hour as opposed to 'half a yard an hour'. What a joke of male domination!

Anyway, I had to go back to that place of horror; the place I left behind many years ago. I do not want to remember what happened to me then, when I was drugged and raped by the very man who is still haunting me – to settle his scores with me because I left him, because he could not keep me in a cage, keep me as a slave. I escaped; I survived his torture and decided to have a life. I wanted a life free of slavery; a modern-day slave, even in Britain. I live in a country which advocates justice and fairness elsewhere in the world but not on its home front. To this day, the loser is still haunting me because I escaped from him. It took a while but I did eventually escape from his cage, and it is better

late than never. He does not realise that 'some birds are just too bright to be caged'. That's me. I do not love him. I never loved him and, no matter what, I know that I am just too beautiful and intelligent to be caged or bullied by a man with very little manhood. A so-called 'man', who uses aggression to control his 'prey': a woman who has a heart and soul… a woman who has the right to basic freedom, at least as a woman.

The loser is a man who seriously suffers from 'little man syndrome'. I have won many battles with him already, and I will win this battle, for I am too bold now, too confident to be bullied by a man like him – or any of his type of men. I'm not going to take any more 'shit' from anyone, especially a man who has no respect for a beautiful, loyal, and intelligent woman. That is me; it's who I am. If I am honest and true in my heart, I will win this battle and put the past behind me. To be myself in a world of loser men like him – men who are constantly trying to make me into something else – would be my greatest accomplishment. I am ready to face my fears, go back to that village, and stand up to them in court, to win this case and put an end to my battle with this loser for good.

It is a difficult road for me but I know deep in my heart that difficult roads can lead to beautiful destinations, so I will face my fear, see what lies ahead, and fight it…

## 3. 'Guns Blazing' Terrors of the Anti-Terror Police

### A 'tacit' licence to terrorise innocent people in the community

On 17 July 2016, a whole 'brigade' of Anti-Terrorist Police with machine guns, hand guns, and other weapons surrounded my house ready to smash my door down with battering rams, and all because they were 'hunting' for terrorists, based on a 'hunch'.

It was around 1.00 a.m. when I was woken by a phone call: "Mum, get downstairs and open the door, police with guns are outside the house!"

Half asleep and angry at my son for waking me, I got up in confusion and quickly put on my robe before running downstairs to see what he was talking about. When I opened the door and saw what was in front of me, I was in utter shock; I simply could not believe my eyes!

At first, I thought perhaps my son had got himself into a fight and that the police had caught up with him, but then I realised it wasn't that at all. It was an Anti-Terrorist raid, about to happen in my house!

Looking out the front door, I saw that the whole of my street had been blocked from both ends, with a number of police vans lined up in the middle of the road, not to mention dozens of armed police pointing machine guns at my son, and others now coming towards me.

My neighbours were having a 'field day' (although it was in the night), with all nearby windows and doors slamming wide open and all eyes pointing at my house, not to mention the passers-by standing around at a distance to try to see what was happening.

I had no option but to remain calm and to invite the police into the house. This was for two reasons – to make sure my son didn't get shot and to get the guns away from him, and to get away from the neighbours and their intrusive stares. Now that I had a much clearer view of them, I noticed the sheer weapon power the police were carrying – machine guns, hand guns, batons, hand cuffs, and more, as well as most of them seeming at least 7ft tall, with heavy built bodies, while I was tiny – less than 5ft nothing.

Furthermore, I noticed the heavy metal bar (the battering ram) that was being carried by one of them; I have no doubt this would have been used to smash my door down if I hadn't answered.

This had only been avoided by the fact that my son was out in the garden smoking, otherwise I'm sure the 'guns blazing' anti-terror police 'squad' would have been smashing my door down; he noticed them and quickly called me to open the door before it could happen.

He'd thought that my house was being burgled and had shouted out, "Who's there?" when he heard heavy footsteps piling up on the streets outside my main door. It was at this point he was faced with the machine guns pointing at him, the police pinning him against the wall and ordering him not to move unless he wanted his brain to get 'blown' off.

Once I'd invited them in and the guns were no longer pointing at my son, I started questioning them about their actions, but frustratingly, they could not provide any good reason; it was apparently a 'hunch' or maybe a tip-off. Those reasons weren't good enough for me, or for my son who was even angrier now than before.

My son had always said that the police are thugs and that they target young Asian Muslim boys for no reason, so he was adamant they'd be looking at him, as he was the only man in the house. Previously, he'd been arrested along with his friends for a crime on a Bedfordshire University student, but was later released. As he left, one of the policemen said, "Sorry guys, all you Asian boys look the same." When we started asking them more questions, it soon became apparent that they didn't have a clue who they were looking for, but they did say they were looking for guns and that they needed to search the premises.

When my son and myself started asking for evidence, they tried to throw their weight around, using bullying tactics and making demands that my son should give them the keys to his car (this was when they found out he owned a car). There was no way my son and I were going to give them any keys without first seeing some proper paperwork from them.

When they tried to throw in some laws for their search, we did our best in return to throw them some legal arguments against their demands. My son said: "I don't trust you lot; you come here all 'guns blazing on a witch hunt' with no idea who you're after or what exactly you're looking for," before further adding, "If I give you my car keys, without a doubt you will 'plant' a gun in there and have me done! You lot are legalised thugs, worse than the normal police!"

He refused to give the car keys to them, and turning to me, he said, "Mum, you are the house owner; if they don't have a warrant you can ask them to leave, so can you tell them to leave now please?"

Agreeing, I said, "My son is right. Did you not do your homework before coming to raid someone's house? You could have at least checked who lives here!" I then went on to add, "The house mainly consists of women and children – including a baby – and you were ready to smash it down while people were asleep?"

My questions were clearly starting to frustrate them, especially as I was recording their every move – they hadn't thought they'd be faced with a professional lawyer holding a video camera up to them, I'm sure. I agreed that without any paperwork I could ask them to leave my house, and that's exactly what I did, calmly telling them to get out. They seemed to think about this for a moment, then said they would leave if my son gave them his name. Of course, as soon as he gave his name, they decided to arrest him.

They gave their reason – on suspicion of possession of firearms – which of course gave them the power to now search my house under Section 32. While my son was taken down to Luton Police Station, the search dogs and other specialist police officers arrived to search my house for guns. My daughters – who were aged twelve and thirteen at the time – had to get up from their beds and rounded up in the kitchen while the specialist team searched every inch of my house and garden – looking for guns based on a 'tip off – a hunch'.

The search did not finish until about 3 a.m. And they found? Nothing! Of course they didn't find anything. What a waste of time, not to mention tax payers' monies.

If my son hadn't been smoking in the garden at the time, the situation could have been much worse, I'm sure; I simply cannot imagine what the scene would have been like if we'd all been asleep and the door had been smashed in, with all the police and their machine guns making their way in to terrorise us, taking us for terrorists!

My son was ill with abdominal pain while being held in the police cell, but he was released the next day, without charge. They had taken his car and his phone, but after making some complaints to the Police Commissioner and threatening to take legal action against them, the items were released to him very quickly.

My message to the Police Commissioner included the following:

"I am aware you are on a WITCH HUNT FOR TERRORISTS, but when you treat ordinary people as terrorists on a 'hunch' without proper evidence, you are not doing any good building a reputation within the community."

## 4. My Struggles and Success at a Glance
*"Born in Bangladesh but made in UK"*

They say, I should not tarnish the community by telling my story of abuse. Abuse which I call torture which happened for no particular reason or reasons apart from the cultural norm and men's ego and insecurities put to the test to prove that he or they are a MAN. What better way to put that to the test than to take it out on the wife and children.

But my justification? – For too long the cultural norm has punished us women and girls even on western soil. Claiming that the husband is superior to the wife, a husband has a right to rape, beat and torture his wife and kids especially daughters. And we are meant to cope with it for the sake of family and community honour. As I have been told "a good woman is a woman who can cope with a bad husband"

Well, **Enough is Enough!** Someone needs to tell it as it is until things change.

The society feel that it's a normal cultural practice and it should continue even on British soil, while the authorities tiptoe on it and turn a blind eye. In my case, the authorities often saw it as a **'typical Asian situation'** not worth the attention.

Anyway, I am not setting out to tarnish anyone now, as I feel that I have achieved that already through personal & legal battles and that in itself is a victory for me.

I am now hoping to inspire others in a similar situation that **"if I can survive, then so can you"**.

You do not have to be in a "typical Asian situation" or suffer any other form of barbaric cultural practices. You too can escape from the terrors of domestic or honour based violence, by fighting for the basic rights as a woman – basic right to freedom. **"There is always a way"**.

At a glance – I was born in a remote village in Bangladesh but privileged to have a British settled father, whom I joined together with my mother and brothers in 1981. I am lucky because my uncle tried to persuade my father to 'dump' my mother in Bangladesh because for a first born, I was born a **girl** and offered his wife and children (sons) for my father to take to the UK. Which according to him, was in the best interest of the extended family. We came to the UK eventually and with us, my uncle did persuade my father to take one of his sons.

However, the son never supported him or his family and my uncle's primitive and barbaric ways of life and big ego got him shot dead in the end, which was another burden from hell for my parents and for myself. Anyway, I became a British citizen soon after. As a result, I also became a target for visa seeking relatives and my problems started but these problems were solved in the end. I am a survivor! I survived forced marriage – engaged at nine, married when barely a teenager. Drugged and raped every night until I got pregnant by my so called husband, in order to secure his visa prospect to the UK. It worked, he got the visa to the UK eventually.

Years of grooming from the time I was born like many other girls, had worked. I was made to believe that my life and heaven lies under the feet of my abusive husband. I thought I was too ugly for the attention of a decent man. **In fact, I actually convinced myself that I was too ugly** and allowed myself to be controlled and abused for many years.

Threats, manipulation, inhuman and degrading treatment was a norm from both the families and the community here in the UK and in Bangladesh. My life was in turmoil, from the

first husband to the second husband. From being beaten up to a point where I nearly lost my eye for revising for an exam to marital rapes every night which is not regarded as rape in my culture, being kicked down the stairs at eight months pregnant, nearly had my throat slashed while holding two of my toddlers – trying to protect them, beaten up with a big bamboo pole, regular slaps across the head, ears and the face which had left me with loss of hearing.

Not to mention the mental torture which included putting me through rituals or black magic practices. These abuses had me admitted into a mental hospital for a while for suicide attempts, until my inner survival instinct opened up and along with my GP's kindness, I pulled through. And of course, the attempted contract killing with my children and the village mob attack which labelled me as a British Bandit Queen. But I survived all that! Yes, ladies and gentlemen I survived. Now they say that **I am too hot to be handled, too wild to be tamed.**

I turned my inner prisoner into a fighter, fear into strength, strength into a weapon, weapon into action and then I LET MYSELF FIGHT UNTIL THE FIGHT WAS DONE.

I may never know what love really is as the 'menkind' I came across never allowed me to experience this. But I smile and salute my struggles of the past as it presents a far better, confident and independent ME. – **I am my own Free Queen.**

Lightning Source UK Ltd.
Milton Keynes UK
UKHW011056110522
402816UK00002B/445